ICONS IN TURKEY

ICONS IN TURKEY

Nilay Yılmaz

A TURİZM YAYINLARI

Cover picture.
The Baptism. Detail. The Sinop Museum.

Editor
Fatih Cimok

First printing 1997
Third printing 2007

ISBN 978-975-7199-46-5

Copyright © A Turizm Yayınları

Publishers
A Turizm Yayınları
Şifa Hamamı Sokak 18/2
34122 Sultanahmet, İstanbul, Turkey
Tel: (0212) 517 44 72 Fax: (0212) 516 41 65
info@aturizm.com

CONTENTS

St John the Baptist with scenes from his Life (81). Detail. The Sinop Museum.

EDITOR'S NOTE

This is the first volume which brings together a considerable number of icons kept in the major museums and the Greek Orthodox Patriarchate in Turkey. At the time that it was being published, all of the icons in this book, except those in the Ayasofya Museum, were on display. In assembling this collection no effort has been made to reach the icons owned by private collectors or individual pieces kept in other museums and churches. The book also includes descriptions of most of these icons. However, no attempt is made to place any of them in the stylistic or the iconographic history of Byzantine art. Also, since the icons included from the Ayasofya Museum have neither been cleaned nor seen any restoration, pictures may not reflect their original colours.

Compared to the interest that the surviving Byzantine architecture, wall paintings and mosaics receive from Turkish and foreign scholars, the icons in Turkey are obviously neglected. There is almost no record of the icons kept in private collections. Those kept in museums need cleaning, restoration and study. Another more general reason is that icons have been regarded less important than Byzantine wall paintings or mosaics and their study has been overshadowed by them. It is only recently that a more careful study of icons began which approached them as a type by themselves, despite their close relationship close relation ship with the other arts.

As far as the provenance of the icons included in this volume is concerned, some of those kept in the Ayasofya Museum are definitely known to have been brought from Russia by immigrants in the reign of Sultan Ahmet I (1603-17). Although some of the icons which are labelled as 'Greek' may have been brought from neighbouring Christian countries, most of them were probably executed by the Greek artists in İstanbul or Anatolia.

The biblical quotations are from the New American Bible, 1987 edition, Nashville, USA.

INTRODUCTION

The word 'icon' derives from the Greek *eikon* meaning 'image,' and originally was used as its equivalent in English to refer to all kinds of sacred images such as frescoes, mosaics, painted boards, reliefs or sculptures. Today however, scholars define only portable panel paintings with images as icons.

While the earliest surviving Christian images — in the catacombs of Rome — date from about AD 200, the oldest known icons[1] date only from the sixth century. Producing icons was easier and cheaper than other representational art forms such as wall paintings or mosaics, and required neither professional artists nor wealthy patrons. It is thought that they were popularly produced and used by early Christians in Constantinople, in the same way that they are still placed on altars or tables, decorated with candles and wreaths of flowers in small chapels and homes. Being of perishable material, however, the icons of this early period did not survive. Iconoclasm and the Latin occupation of Constantinople were also responsible for the disappearance of old icons.

The attitude of the Church towards icons was formulated by St John of Damascus (*c* 675-749). Although written to invalidate the claims of iconoclasts, his view is regarded as the teaching of the Church on the subject from the very beginning of the production of icons. In the Old Testament, God prohibits the making of his image. Deuteronomy (4:12) reads

'Then the Lord spoke to you from the midst of the fire. You heard the sound of the words, but saw no form; there was only a voice.'

Thus speaking of himself and making clear that he is invisible — both to people and Moses — God forbade the production of his image. Since he was not seen, how could his image be made? However, with the Incarnation the situation changed. The invisible God had desired to become visible with the Nativity and thus the painting of his image became permissable.

(opposite) The Crucifixion (25). Detail. The Ayasofya Museum. İstanbul.

[1] Those kept in the monastery of St Catherine in Sinai

In Deuteronomy (4:15-19) after prohibiting the making of his image God also prohibits the making of images of creatures:

'You saw no form at all on the day the Lord spoke to you at Horeb from the midst of the fire. Be strictly on your guard, therefore, not to degrade yourselves by fashioning an idol to represent any figure, whether it be the form of a man or a woman, of any animal on the earth or of any bird that flies in the sky, of anything that crawls on the ground or of any fish in the waters under the earth. And when you look up to the heavens and behold the sun or the moon or any star among the heavenly hosts, do not be led astray into adoring them and serving them.'

It is clear that the Old Testament prohibition of images is based on the fact that in the absence of the image of God reproductions could easily lead to idolatry; that is they could be worshipped in place of God. Exodus (20:5) and Deuteronomy (5:9) repeat this saying: 'you shall not bow down before them or worship them.'

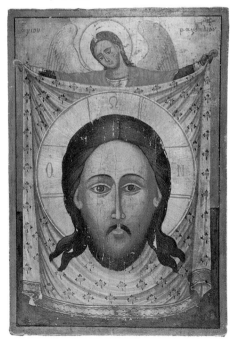

The Holy Cloth.

But when the image of God existed there was no danger of worshipping other images. In addition, the Old Testament does not prohibit all figured images. In Exodus (25:18) after finishing the Temple, God asked Moses for the two ends of the throne of Mercy to make 'two cherubim of beaten gold.' Ezekiel also mentions palm trees as ornaments in addition to the cherubim with men's and lions' faces (40:16,31; 41:19). The paintings which have survived on the walls of a synagogue in Dura Europos show that images were tolerated as early as AD 300. Consequently the making of images to glorify God, images of saints, angels, holy men and women could not be regarded as a sin.

According to the Christian tradition the first icon was created by Christ himself. This was a portrait of Christ which was said to have come into existence without human involvement (*acheiropoietos*). The story of this icon has survived in several forms and according to one version of it King Abgar of Edessa (Urfa, in Turkey), who suffered from leprosy, sent an envoy begging Christ to visit and heal him. If this was not possible his man, who could paint, was to make a portrait of Christ and bring to him. The man's efforts to make a portrait of Christ were futile because the face of the Lord bore glory that changed 'through grace.' Seeing this, Christ asked for water,

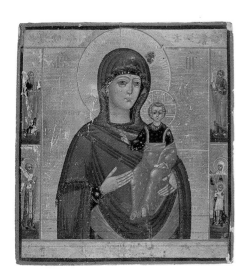

The Virgin of the Way.

washed his face and wiped it with a piece of cloth on which his features remained imprinted. Afterwards he sent the cloth to Abgar together with a letter and thus Abgar was cured from his disease. After a short while the king placed the image above one of the city gates. His great grandson, who was a pagan, wanted to destroy the holy image. However, the bishop of the time had made a niche in which it was placed and which was then walled up with a burning lamp inside. The holy image and the still-burning lamp were discovered in the middle of the sixth century when Chosroes I, king of the Persians, besieged Edessa. The image was intact and it had been imprinted on the inner side of the tile which concealed it. Thus the first icons — on cloth and on tile — were created. The icons of the Holy Face commemorate this event, showing the face of Christ represented respectively on a piece of cloth or imprinted on the tile. The style on the piece of cloth came to be known in Greek as the *mandylion*, or holy cloth. Sometimes two angels standing on either side of the face and holding the white cloth are added.

Tradition has it that the icon was bought in Edessa by Constantine Porphyrogenitus and Romanus I and brought to Constantinople in the tenth century and placed in the church of the Virgin of Pharos in the Great Palace. After the sack of the city by the Crusaders in 1204 all trace of the icon was lost.

A late Latin tradition has it that as Christ stumbled under the cross on his way to Golgotha, a woman named Veronica stepped out of the crowd and wiped the sweat from his face (the sixth station of the cross) and his features were imprinted on the head-cloth she had used, and thus the first icon was created.

The earliest icon of the Virgin which has found its place in Christian literature is the famous icon of *Theotokos*, the 'Mother of God' represented with the Child. This was called the *hodigitria*, the word in Greek meaning 'showing of the way'. It is thought that the original was painted by St Luke from life. The icon was a *palladium* (protector) of the Byzantine Empire. It had been discovered by the Empress Eudoxia and was sent to Pulcheria, the pious sister of Theodosius II (408-50), who kept it in the church of the monastery of Hodgeon. The icon was attributed with special powers and became the protector of the capital, being carried along the walls of the city during sieges. In May 1453 when the Ottomans besieged the capital it was paraded up and down the city walls for the last time and prayers were offered to it in the church of Chora.

A second type of icon of the Virgin thought to have been painted by St Luke is known as the *eleousa*, or 'tenderness'. This represented her caressing the Child, an act of a mother foreshadowing the inevitable end of her son.

St Luke is claimed as the originator of a third type of representation of the Virgin. This type showed her without the Child, and probably in the fashion in which she is represented in Deisis compositions with her hands extended imploring for the salvation of mankind.

Christianity was born into a world of Judaism and pagan beliefs and cults and its art exploited the rich available repertory of Greco-Roman and Judaistic symbols and subjects. It copied from what was available and gave it its own meaning. Although no sample survives from the early period, the tendencies encountered in early wall paintings were probably also valid for icons. The first icons probably included ancient pagan or Judaistic symbols and were executed with great simplicity. In the beginning a few strokes and a limited range of colours were enough for the Christians to find the meaning of a story with which they were already familiar and for them to use these images for liturgical purposes. When it was discovered that a growing number of new converts were unable to understand the hidden meaning of symbols, subjects whose meaning could be understood more easily became necessary. Gaining a didactic role the production of icons must have flourished, as was the case with mural paintings. The Church began to use painting alongside words. A Greek philosopher inspired the representations of Christ, an apostle or a prophet; representations of nature inspired the Good Shepherd; representations of apotheoses of Roman emperors evolved into those of the Ascension. The nimbus of the personified Sun, a motif which probably originated in the Persian cult of Ahura Mazda was adopted to show the heavenly illumination around the head or entire body of Christian figures. Natural motifs such as those of palm trees; the dove or the peacock became the motifs of a heavenly paradise.

In order to convey the inner meaning of the image, from the very beginning of the production of icons aesthetic or artistic elements were deliberately eliminated or reduced to a minimum. For instance, even if the early portrait icons were inspired by the Roman tradition of producing portraits of emperors, family members or of people of rank, the result was different. In the Roman prototypes the portrait was intended to

The Virgin of Tenderness.

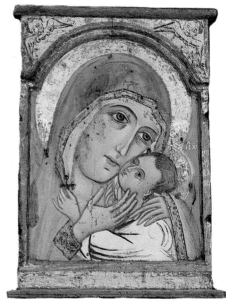

bear the likeness of the individual it represented as closely as possible; whereas in Christian icons the physical resemblance was not sought after. In some cases a few characteristic traits were retained. Today only the portraits of some bishops can be traced back to their images taken from life. The imitation of the established canon and the passing on of tradition were the only objectives. The models used were those of old icons. The icon of Christ was a mirror of the Lord of the Universe. As such, Christ had to be shown with long hair in the fashion of the Christians consecrated to God and with a beard and dark eyes. His image had to be rendered frontally so that the worshipper could communicate with him as easily as possible. Contrary to the modern tendency, a Christian artist strove not to disclose anything personal in his work.

The images of Christ and those of the Virgin — with or without the Child — were followed by those which showed the apostles, martyrs, angels and narrative scenes from the Old or New Testament.

The acceptance of Christianity as the religion of the palace in the beginning of the fourth century — also the moving of the capital from Rome to Constantinople — was the sign of the beginning of a new epoch in Christian art. It showed the end of the age of martyrdom and beginning of the age of theologians and ascetic saints. The surviving Christian literature shows that most of the Church Fathers of the period regarded images in the teaching of Christianity more effective than words or books; the making of images, illustrated books, frescoes, mosaics and icons flourished.

The history of the reaction against Christian images is as old as the beginning of Christian art. The writings of the Church Fathers show that some of the early Christians accorded Christian images the same meaning that they had to the pagan images and used them as objects of superstition or idolatry and by the sixth century there was a thriving industry of commemorative objects, such as lamps, medals or phials decorated with Christian symbols or images. For some people such objects were more than souvenirs and worshipped in their own right. They were thought to possess the protective and apotropaic power of what was depicted on them. Costumes or accessories with religious images were worn with the belief that they protected the wearer from sickness or evil. However, this was something which could be corrected by the teaching of the doctrine of the Church on images. The arguments brought forward by Judaistic teaching and the Monophysites were stronger. The

objection of Jews to images was formulated by the teaching of the Old Testament as already has been mentioned. For the Monophysites the humanity of Christ was inseparable from his divinity and the effort to represent the *aleptos* (incomprehensible; imperceptible) was useless. Drawing an image of Christ was trying to separate his humanity from the divinity. Nevertheless, until the succession of an iconoclast emperor to the Byzantine throne such sentiments remained merely as issues of doctrinal argument.

Iconoclasm was the result of all kinds of social, political, religious and economic tensions of the empire in the eighth century. The emperor Leo III (717-41) was known as the 'Isaurian' — from Germanicia (Maraş, in Turkey) — because he was thought to have come from northern Syria where there were iconoclastic sentiments influenced by Judaism and Islam.[2] His sincere opposition to the veneration of icons was shared by most of the bishops of the eastern provinces. In 726 he ordered all icons removed from churches and a systematic destruction of icons and persecution of iconodules began. The first image chosen was the great mosaic of Christ which stood above the Gate of Chalke of the Great Palace. Leo dismissed the iconodule patriarch and gave the post to somebody who could issue an edict against images.

The destruction was most merciless in the capital. The icons were gathered in public squares and burned. The mosaics and mural paintings were scraped off or obliterated. In some cases they were replaced by landscape scenes or crosses.[3] Those who hid them were tortured or killed. Hundreds of iconodules escaped to Italy or Greece taking with them icons hidden beneath their garments. Some followed the example of their grandfathers who had escaped from the Saracens and chose to migrate to the uninhabited valleys of Cappadocia.

The edicts of Constantine the Great and his pious Christian successors had exempted the clergy from financial and military obligations. The practice is said to have led both to the accumulation of considerable wealth in the hands of monaster-

Iconoclasts whitewashing an icon of Christ. Barberini Psalter. Twelfth century. The Vatican Library. Rome.

[2] Islam tradition has it that if an artist does not have the power to give life he should not imitate the creation of God for he would be asked to give life on the day of Judgement to what he painted on earth.

[3] Such as the cross, which has survived to the present day, in the apse of the former church of St Irene (The Aya İrene Museum) in the capital. It was put there when the edifice was rebuilt following an earthquake in 740.

ies and made religious posts more popular jobs than serving in the army. In addition to the fact that most of the army was recruited from the eastern provinces, the iconoclast emperors are said to have wanted to curb the power of the monasteries and churches which had began to threaten their authority.

Although an iconoclast, Leo IV (775-80) eased the persecutions during his reign because of his wife Irene, who was a believer in icons. Upon the death of her husband Irene became regent for her ten-year-old child Constantine VI (780-90) and brought an end to Iconoclasm.

The economic, military and political failures of her reign made Irene very unpopular with her subjects and she was overthrown. Her immediate successors were iconodules like herself, but in 813 the military leaders, who were still iconoclasts in part put Leo V the Armenian on the Byzantine throne. The latter sincerely believed that the situation in which he had found the empire was the result of the veneration of images and he reinstated Iconoclasm. However, compared to its first application this phase was more moderate. It lasted until the end of the reign of Theophilus (829-42), and came to an end with the succession of his three-year old son Michael to the throne, with the iconodule mother of the child, Theodora, as regent.

Until the appearance of the monumental iconostasis the use of icons was limited to homes or chapels. The low chancel screen which separated the sanctuary from the rest of the nave was not suitable for hanging icons. During the Middle Byzantine period this took the shape of the templon and during the Late Byzantine the iconostasis. In the big churches this screen was a massive construction in wood or marble with a door at its centre and other doors, on either side. The central door with two leaves, known as the royal doors or sanctuary doors was used by the clergy. The side doors served to take the gifts or vessels of ritual in and out of the sanctuary. This high iconostasis not only separated the sanctuary where the altar was kept but hid it from the eyes of congregation. The sections at either side of its leaves were separated into horizontal and vertical registers. At its fully developed form these registers were used to display icons in such a way that the congregation would conceive iconostasis as a cosmos reflected on a screen. The Deisis icons, feast icons, the icons of Old Testament figures and others, would occupy their places on the screen according to the iconographic hierarchy. In course of time, icons imita-ting the iconostasis ('sanctuary doors' or 'royal doors') were produced.

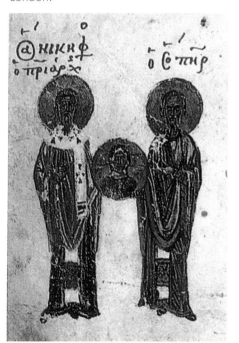

Theodore the Studite and Patriarch Nikephorus carrying an icon. Detail from the Studite Psalter. c 1066. The British Library. London.

St Paraskeve (5)
Detail. The Greek Ortho-
dox Patriarchate. İstanbul.

ICONS
from the
GREEK ORTHODOX
PATRIARCHATE, İSTANBUL

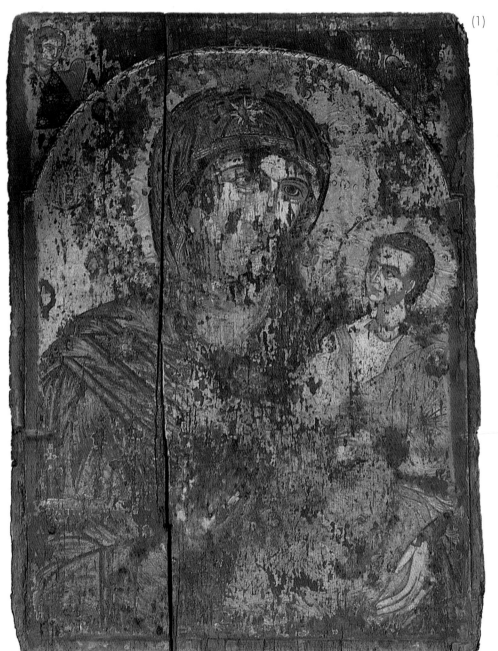

The Virgin of the Way (1)
Greek
Twelfth - thirteenth centuries
104 x 70

The icon is thought to have come from the Monastery of 'Panaiya Faneromeni' near ancient Kyzikos on the Asiatic coast of the Marmara Sea and was known as 'the Virgin of Kyzikos'. It was atributed with healing powers.

The representation is inset in a hallowed arch with spandrels adorned with the archangels Gabriel and Michael. The icon shows the Virgin and Child in the *hodigitria* manner; with her raised open right hand pointing at the latter. The silver mount of the icon is from the nineteenth century.

(1)

The Virgin Pammakaristos (2)
Greek
Mid-twelfth century
85 x 60

The Virgin is shown with the Child on her left arm, in the *hodigitria*, or one 'who shows the way' manner. The Child is shown with his face slightly turned up looking at his mother. His right hand is extended in blessing. In the other hand he holds a scroll. In the upper right corner, the bust of an angel is represented.

The mosaic icon[1] is thought to have stood on the right side of the templon of the former church of the Virgin Pammakaristos[2] (Fethiye Mosque) that was founded by John Komnenos[3] in the middle of the twelfth century, and was moved to the Greek Orthodox Patriarchate[4] in the late sixteenth century before the church became a mosque.

The nimbi of the Virgin and the Child were originally of gilded gesso, a fashion imported from the West. Together with the icon of St John the Baptist they were restored in imitation of mosaic work in 1933. Both icons are thought to have been cut down.

St John the Baptist (3)
Greek
Mid-twelfth century
95 x 62

St John is dressed in a short-sleeved chiton and a himation. His extended right hand is in the act of blessing. In the other hand he holds an open scroll. The inscription in Greek, reads *Behold, the Lamb of God who takes away the sins of the world* (Jn 1:29). In the upper left corner there is the bust of — presumably — Christ. From the donor represented at his feet only the head and hands remain. This is thought to represent John Komnenos, the founder of the church of the Virgin Pammakaristos, and the icon probably stood on the left side of the templon of the church.

[1] Portable mosaic icons became a fashion during the Late Byzantine period in the declining economic conditions of the time when producing large mosaics became too expensive. The technique used was inbedding tesserae on a panel coated with wax.

[2] The 'Joyous Mother of God'.

[3] The relation between the name of the founder and that of the Byzantine imperial family is thought not to go beyond similarity.

[4] Both icons are on display in the Patriarchal church in İstanbul.

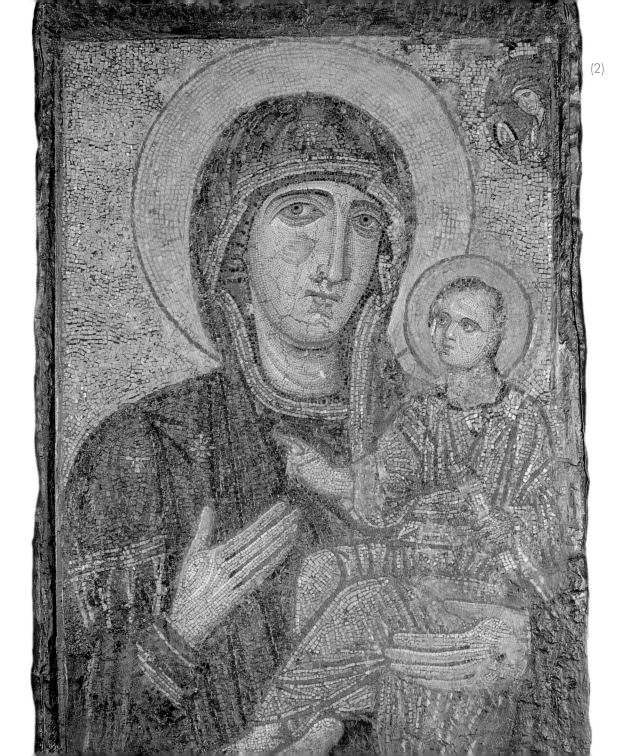

(3)

Ὁ Ἅ(ΓΙΟC) ΙΩ(ΑΝΝΗC) Ὁ ΑΓΙΟC

+ Ι ΔΕ Ὁ Α
ΜΝΟC ΤΟ
ΘΥ Ὁ ΕΡΩΝ
ΤΗΝ ΑΜΑΡ
ΤΙΑΝ ΤΟΥ
ΚΟCΜΟΥ

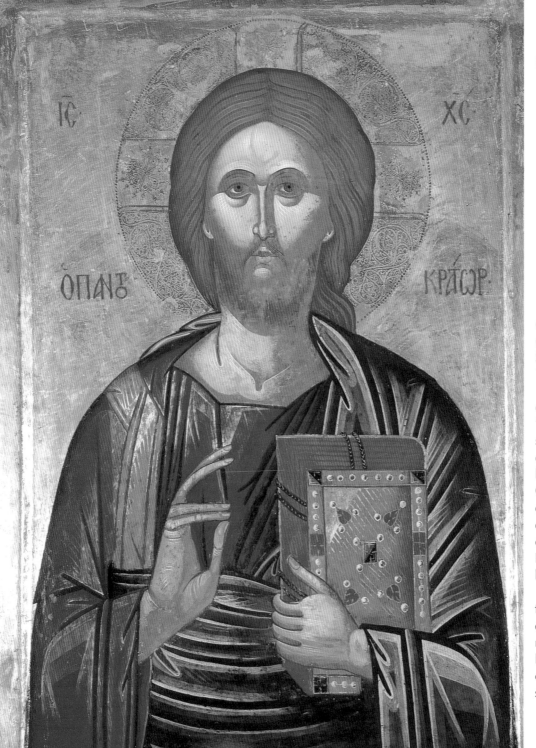

Christ Pantocrator (4)
Greek
Sixteenth century
122 x 86

The icon represents Christ as the 'Pantocrator,' the 'Lord of the Universe.' He is shown facing front, standing and half-length. His left hand clutches a book of Gospels whose cover is adorned with precious gems and pearls. The book is closed with leather straps. His other hand is raised to his chest and blesses.

Christ is dressed in a chiton decorated with clavi and a himation. His head is adorned with a cruciform nimbus. Both the nimbus and arms of the cross are enhanced in shallow relief.

(5)

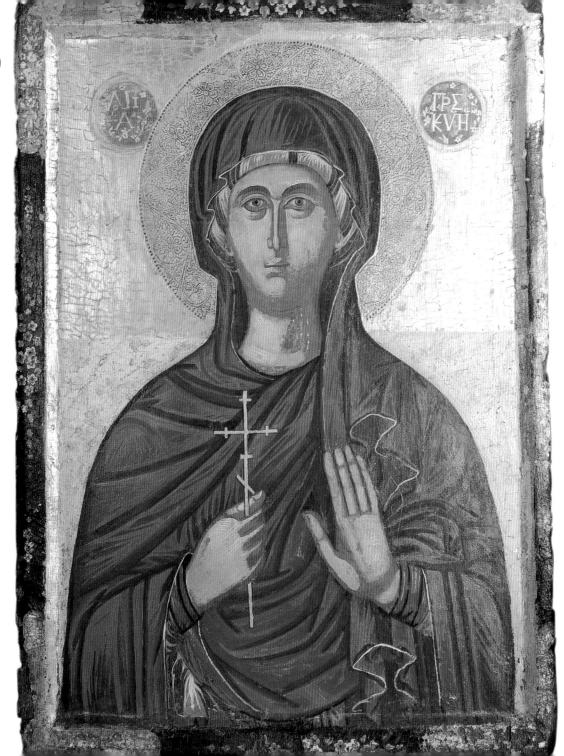

St Paraskeve (5)
Greek
Seventeenth century
94 x 63

The icon represents a half-length figure of the martyr healer-Saint Paraskeve. Her name derives from her birthday on Friday. In her right hand she holds a six-armed cross with a slanting arm, the latter symbolizing the body of Christ. The vertical and horizontal arms are further accentuated in the form of smaller crosses. Her other hand is raised with its palm open outward in a gesture of prayer.

She is dressed in a blue stole with brown cuffs and a red maphorion which covers her cap like a hood and falls on her shoulders and down over her forearms. The border of her cap rendered in tones of blue is displayed around her face which bears the calm and confident expression of a doctor.

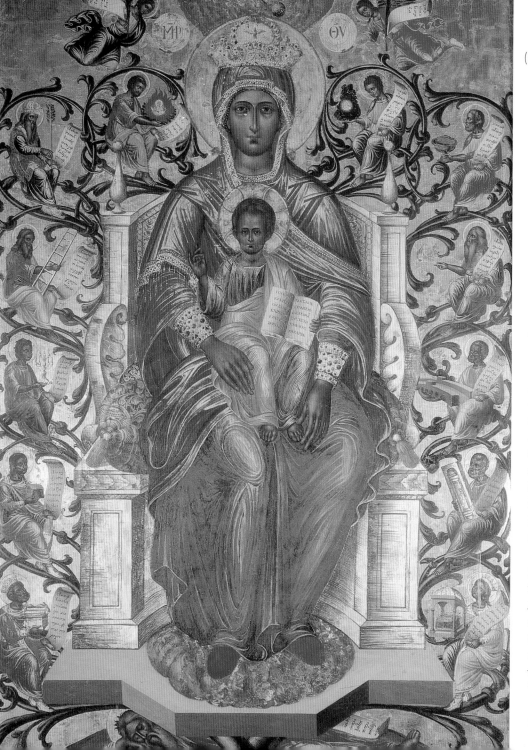

(6)

The Virgin and Child and the Tree of Jesse (6)
Greek
Nineteenth century
190 x 130

In the Old Testament the prophet Isaiah (11:1-2) foretells the descent of Christ, the Messiah, from the royal house of David: 'But a shoot will sprout from the stump of Jesse, and from his roots a bud shall blossom. The spirit of the Lord shall rest upon him.'

The icon shows Jesse — father of King David — lying asleep on the ground. On the branches of the tree, which grows out of his body, twelve of the figures showing the genealogical descent of Christ are represented holding open scrolls alluding to the coming of the Messiah in their left hands. In the other hand each holds a tribute, i.e. in the upper left side Adam a green branch and Moses, the burning bush.

The centre of the icon is occupied by the figure of the enthroned Virgin and Child. Above, two angels are represented carrying palm branches and open scrolls and her monogram acknowledging that she is 'Theotokos,' the 'Mother of God.'

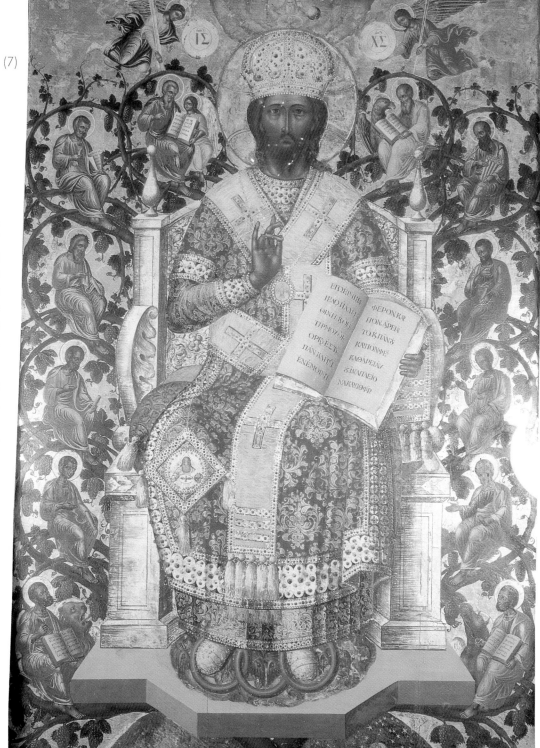

(7)

Christ Pantocrator (7)
Greek
Nineteenth century
132 x 90

The icon shows Christ enthroned as the 'Pantocrator,' the 'Lord of the Universe' at the centre of a vine scroll on whose branches the Twelve Apostles are represented. The Four Evangelists flank his head and feet in pairs with their tributes; a lion, a bull, a human and an eagle and each with an open book of Gospels in his lap. The other apostles are shown in gestures of acknowledgement. Christ has raised his right hand in blessing and in the other hand holds an open book of Gospels. He is dressed in sumptuous bishop's vestments. His feet rest on clouds borne by cherubim.

Above, two angels bearing the instruments of the Passion — cross, spear, and sponge — and monograms of his title are represented. From God the Father the dove of the Holy Spirit descends on Christ's head.

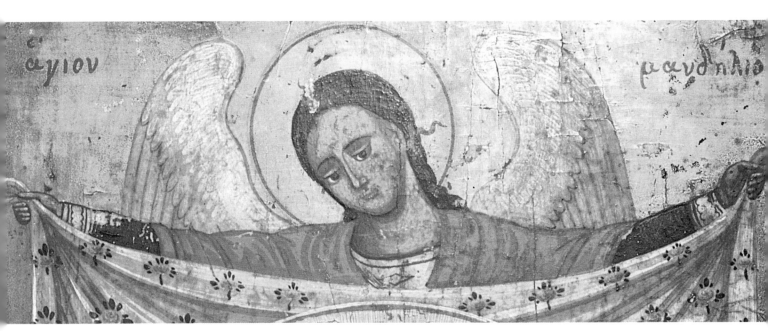

The Holy Cloth (8). Detail. The Ayasofya Museum. İstanbul.

ICONS
from the
AYASOFYA MUSEUM, İSTANBUL

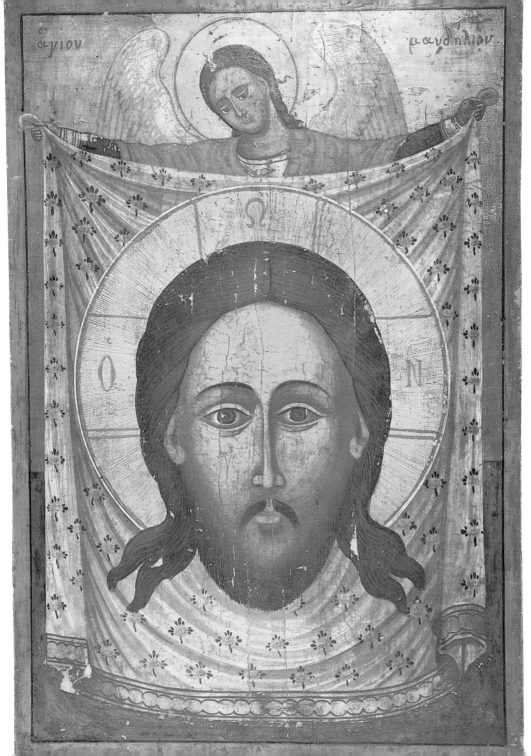

(8)

The Holy Cloth (8)
Greek
Eighteenth century
49 x 34
13629

The Holy Cloth (9)
Russian
Eighteenth century
21 x 17,5
13637

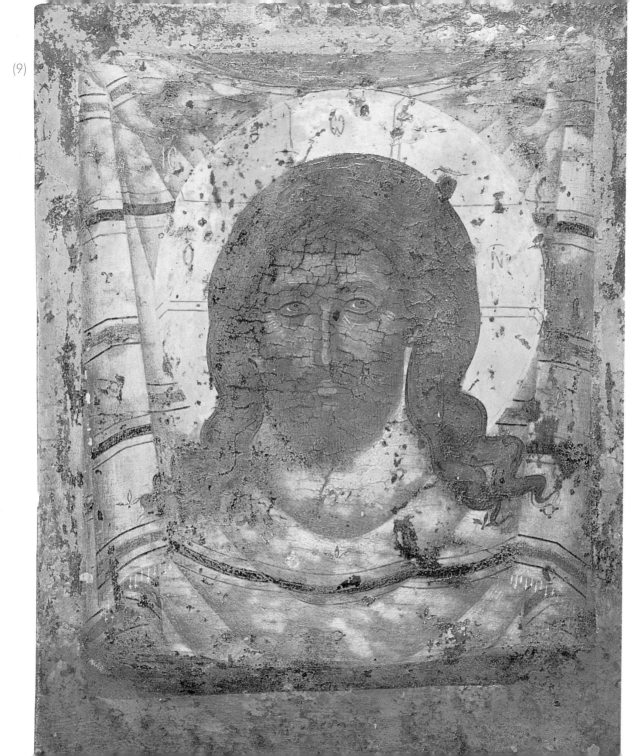

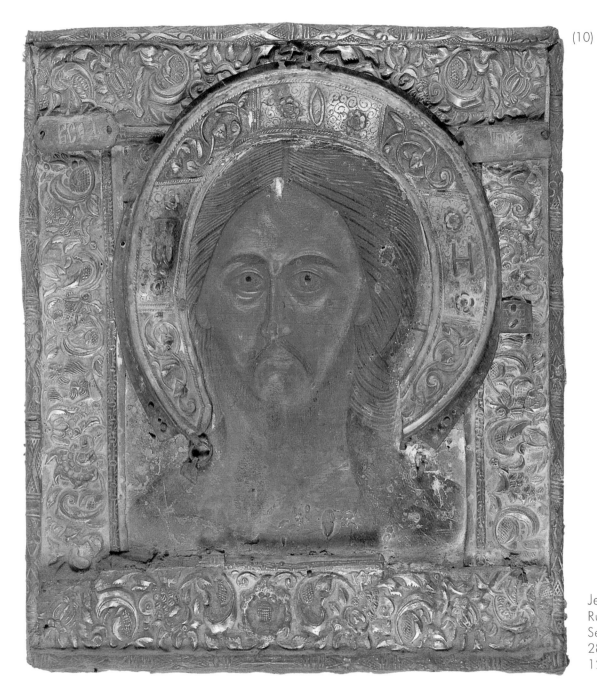

Jesus Christ (10)
Russian
Seventeenth century
28 x 24,7
12992

(11)

Christ Immanuel (11)
Russian
Seventeenth century
32 x 25
12991

The Hebrew word 'Immanuel' stands for 'God [is] with us,' an allusion to the words of the prophet Isaiah (7:14 and 8:8): 'Therefore the Lord himself will give you a sign: the virgin shall be with child, and bear a son, and shall name him Immanuel.'

Here, the name is given to a child who is not yet conceived with the promise that the danger threatening Israel from Syria and Samaria will pass "before the child knows how to refuse evil and choose the good." Thus the child and his name is a sign of God's graciousness; a saving pre-sence among his people. Matthew (1:23) also recounts that in order to fulfill what the Lord said through the prophet Isaiah, 'the virgin shall be with child and bear a son, and they shall name him Immanuel, which means "God with us," or "the Son of God." '

Like the rest of the images which are grouped under the title, the icon shows the Child with the features of an adult with a very large forehead full of wisdom. His nimbus extends on the large margin of the icon on three sides.

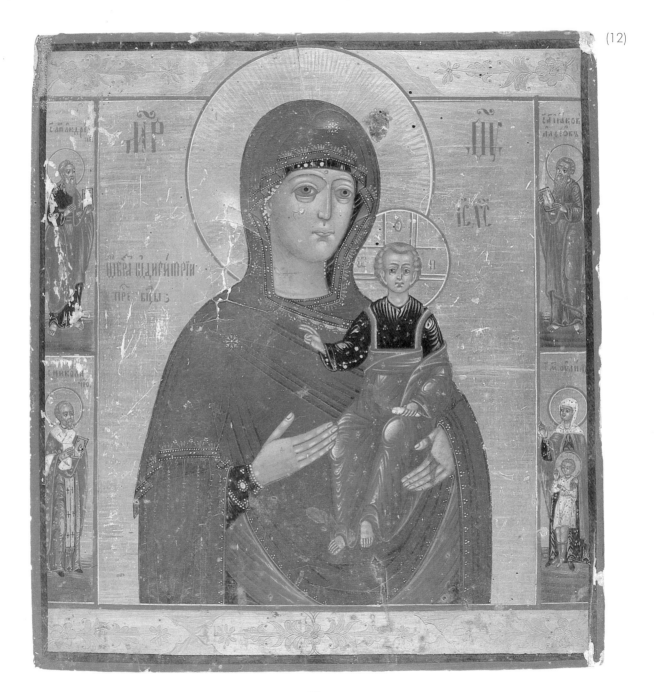

The Virgin of the Way (12)
Russian
Eighteenth century
31 x 29
13135

The icons of this type are known as the 'Virgin Hodigitria,' the 'Virgin of the Way,' in the sense that the Virgin acts as a guide for the believer and shows him the way to Christ. Such icons were often named after the place where they were first produced. After many years they were often claimed to have appeared miraculously.

The icon in the picture is known as the 'Smolensk Hodigitria' type; that is, painted in the city of Smolensk or after a prototype produced there. Tradition has it that the first icon of the 'hodigitria' arrived in Russia in 1046 when the Byzantine Princess Anna was married to Vsevolod of Chernigov. Later it was given to Cathedral of Smolensk and became one of the most popular national miracle-working icons and is thought to have played a part in the victory of the battle of Borodino against the French in 1812.

The icon shows the Virgin half-length and slightly in three-quarter view with the Child seated on her left arm. She is vested in a black stole visible only at the wrist of the right arm where it is embroidered with pearls. Her dark blue cap is visible above her arched eyebrows and on either side of her face. Her burgundy-purple maphorion displays its red linen at the front. On the shoulder and above the fore-head it is adorned with three stars signifying her perpetual virginity[1] before, during, and after the birth of Christ. The border of the garment is embroidered with pearls. It covers her head like a hood and falling on her shoulders hangs down from her forearms. The red lining creates a semicircular arch at the front. With her right hand she points away from herself to the Child. Her nimbus extends onto the upper band of the icon. The Child's head is adorned with a cruciform nimbus. His right hand is extended in blessing. His other hand which holds a scroll rests on his left thigh.

In the marginal scenes pairs of saints are depicted.

[1] Also claimed to represent the Holy Trinity.

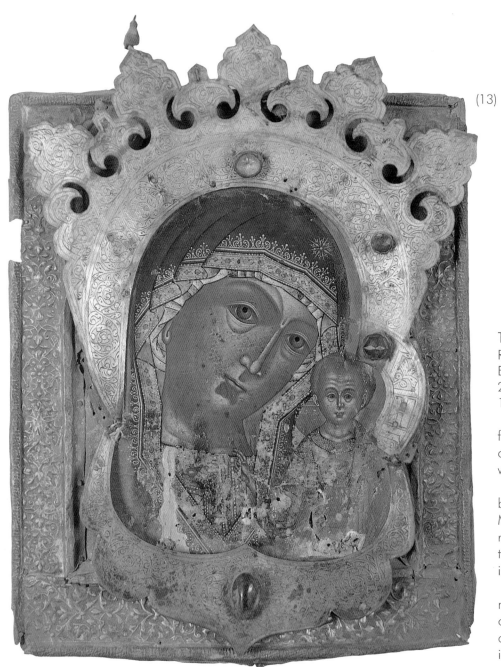

The Virgin of Kazan (13)
Russian
Eighteenth century
28,7 x 24,5
13014

The icon shows Christ Child almost full-length and standing on the left side of the Virgin who inclines her head towards him.

The original of the style is said to have been discovered by a girl named Matrona and her mother among the ruins of a building in Kazan, its location having been revealed to the girls in dream by the Virgin.

It is believed that the icon accompanied the army, together with the icon of 'Vladimirskaya' when it freed Moscow from the Poles in 1612 and during its war with Napoleon 1812.

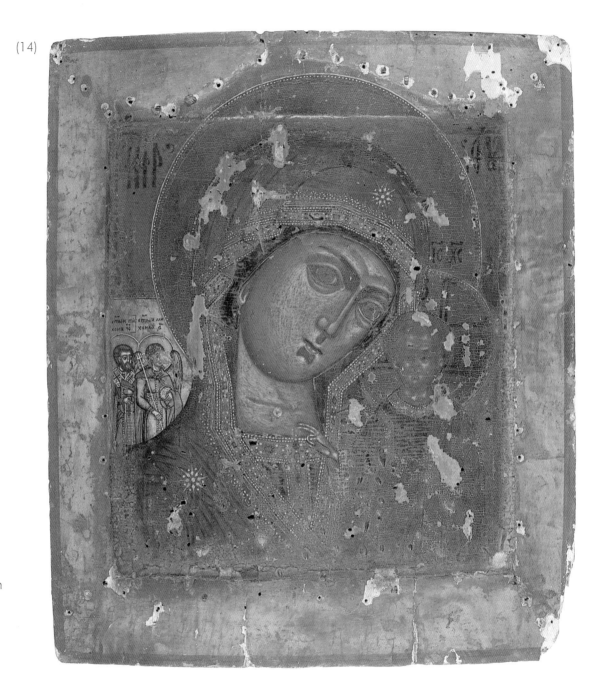

(14)

The Virgin of Kazan
(14)
Russian
Sixteenth century
31 x 27
13013

(15)

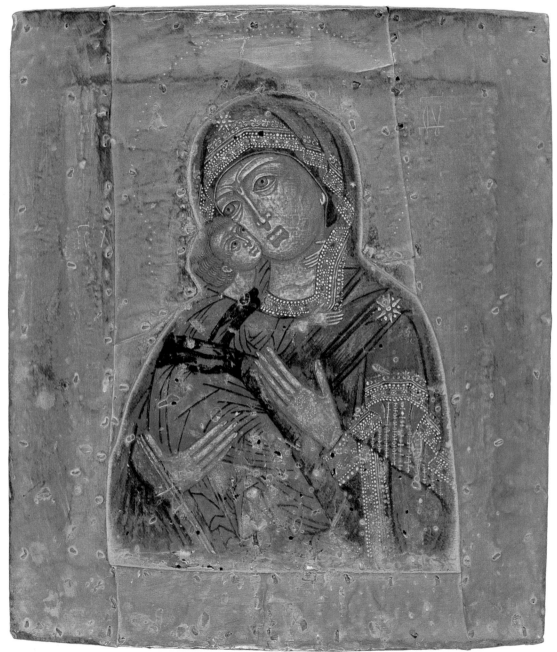

The Virgin of
Tenderness (15)
Russian
Sixteenth century
30,5 x 27,5
13018

The Virgin of Tenderness (16)
Greek
Eighteenth century
37,5 x 26,5
13615

The representations of the 'Virgin Eleousa,' the 'Virgin of the Tenderness' or 'Mercy' constitute a large group of the icons of the Virgin. These show her caressing the Child held on her left or right side in the manner of a loving mother who is conscious of the fate of her child; their heads together, cheeks touching. Such icons were attributed with miraculous power and often named after the place where they were painted.

The piece in the picture must have been the central part of a triptych. The representation is inset in an arch with its spandrels filled with winged angels. It shows the Virgin holding the Child tightly to her bosom with both her hands in an act of maternal protection. Their faces are pressed in reciprocal tenderness. The Child holds a scroll.

The Virgin is dressed in a blue stole on which is a light brown maphorion with a lighter brown edge. Her head and shoulders are decorated with four-petalled stars. Her hair is hidden in a blue cap. The Child is vested in a chiton and himation of light tones of yellow.

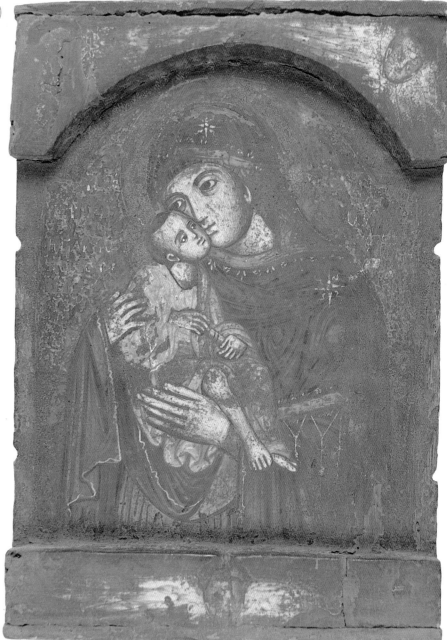

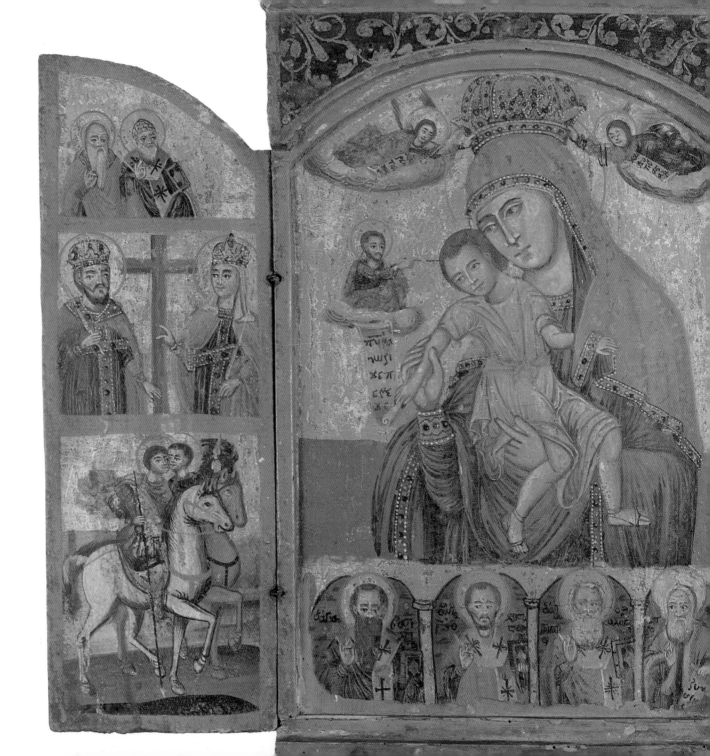

(17)

The Virgin of Tenderness Surrounded by Prophets and Saints (17)
Russian
Eighteenth century
28,5 x 49
13613

Christian tradition has it that the first icon of the *eleousa*, 'tenderness' or 'merciful' type of the Virgin was painted by St Luke from life. It was believed that the portrait of the Virgin and Child appeared to him in a vision.

The central part of the triptych represents St Luke seated on clouds and painting an image of the 'Virgin Eleousa,' the 'Virgin of Tenderness.'

The Virgin holds the Child tightly with both hands and touches her cheek to his. The right hand of the Child is on the end of the open scroll which hangs from the cloud on which St Luke is seated. Above, two angels bearing open scrolls are in the act of crowning her, as the Mother of God.

Beneath, are the figures of (from left to right) Sts Basil, Chrysostomos, Gregory the Theologian and one other. The leaves of the triptych are decorated with saints.

The Virgin (18)
Greek
Sixteenth centruy
28 x 12,5
13616

The Deisis Cycle

The Virgin (19)	Christ Pantocrator (20)	St John the Forerunner (21)
Russian	Russian	Russian
Eighteenth century	Eighteenth century	Eighteenth century
40,5 x 34,5	40 x 37	40 x 37
13026	12995	13047

The composition of the Deisis, or 'Entreaty' is an expression of the idea of saints and especially the Virgin and St John the Baptist, interceding with Christ on behalf of mankind. Often it shows only the Virgin and St John the Baptist on either side of Christ turning to face him.

These three icons constitute a composition of the Deisis and represent the three figures half-length. Each figure is accompanied by its monograms in pairs of baroque medallions. Christ is shown at the centre with an open book of the Gospels which reads *Stop judging by appearances, but judge justly* (Jn 7:24).

On the left, the Virgin holds another open scroll which reads *Ruler most gracious, Lord Jesus Christ, give ear to my prayer.*

Opposite her and on the other side, St John is represented holding a chalice, with the nude Child, representing Christ or the Lamb of God, the most important element of the Eucharist. His gospel reads *Behold, the Lamb of God, who takes away the sin of the world* (Jn 1:29).

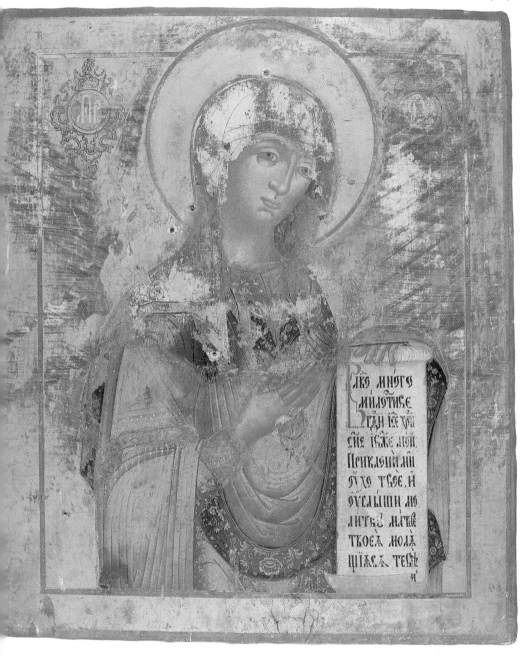

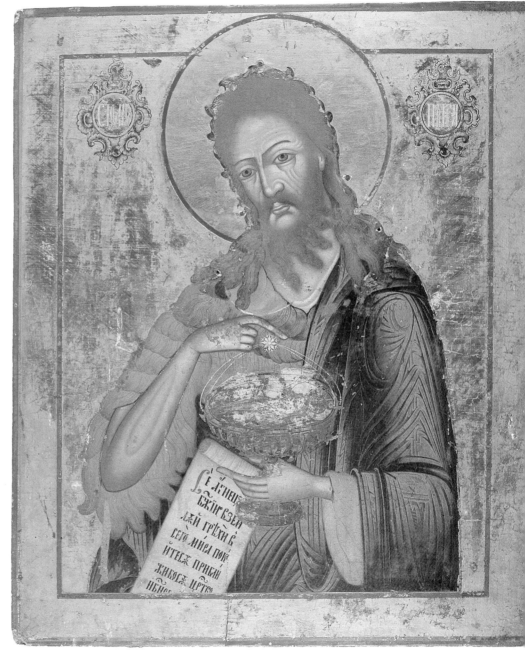

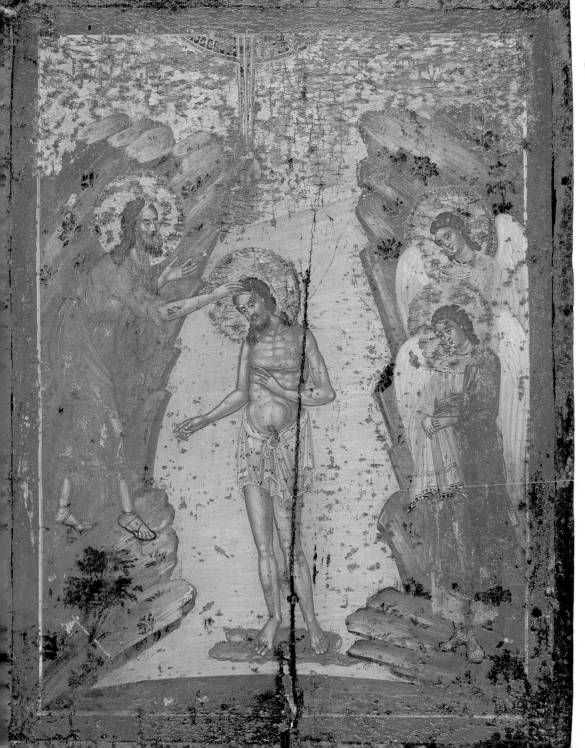

The Baptism (22)
Greek
Seventeenth - Eighteenth
centuries
38,5 x 30
13789

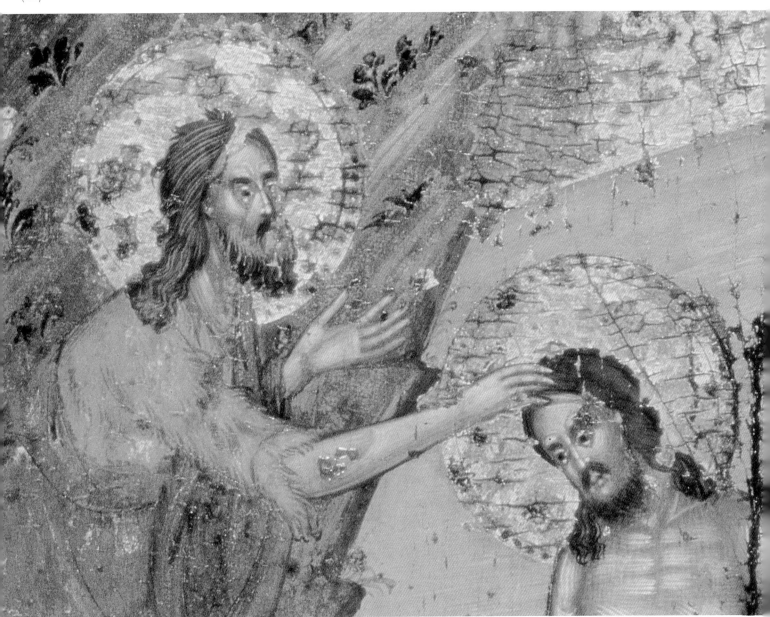

The Raising of Lazarus (23)
Greek
Seventeenth century
38 x 28
13621

This is one of the last miracles of Christ. Lazarus, a close friend of Christ and the brother of Sts Mary and Martha falls ill. The sisters send for Christ and Martha goes out to meet him. Mary follows, with the news that their brother is dead. Nevertheless, Christ informs them that their brother is not dead but sleeping. At the tomb where Lazarus has lain for four days, Christ calls in a loud voice, 'Lazarus, come out' (Jn 11:1-44), and the latter comes out alive, still bound in his grave clothes.

The icon follows the Byzantine tradition of rendering the scene of the Raising of Lazarus in detail. At the centre and to the left Christ is shown standing erect and made prominent by being drawn larger than the other figures on the icon. His right hand is extended forward in the act of blessing. His other hand, which is hidden by his himation, holds a scroll. The golden nimbus around his head bears a cruciform cross inscribed with his monogram.

Opposite him is Lazarus wrapped in a white shroud of swaddling cloth in a rectangular chest. Below, is a youth lowering down the lid of the chest. On the other side of the coffin two young men are represented. The one who is standing has turned his eyes to Christ in surprise and points at Lazarus with his left hand. The third young man is bent forward to the tomb, his head turned towards Christ. While his right hand holds the end of the shroud to unwind it, with the other he tries to raise Lazarus.

Behind Christ are his disciples. On the other side and between the rocky cliffs, which represent the countryside outside Bethany, where the event takes place, are the citizens of the town. At the bottom of the icon Martha and Mary, the sisters of Lazarus are represented in *proskynesis* or 'veneration' at the feet of Christ.

Η ΕΓΕΡCΙC ΤΟΥ ΛΑΖΑΡΟΥ

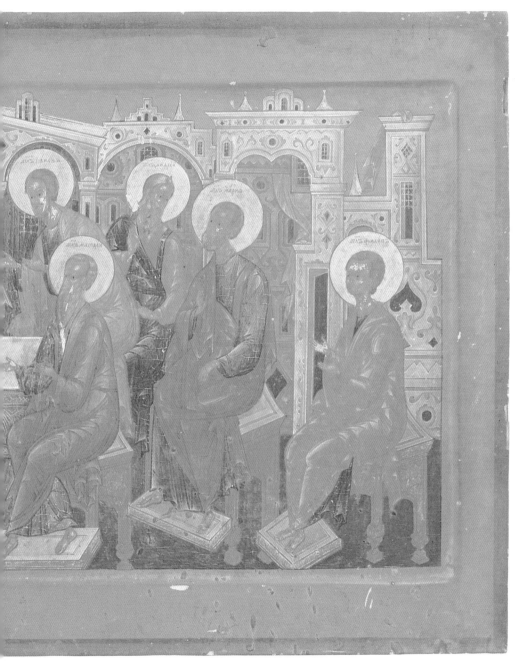

The Last Supper (24)
Russian
End of the nineteenth century
44,5 x 92,5
13125

This is one of the most popular subjects of icon painting because it represents the institution of the Holy Communion. The event takes place in the upper room of a house in Jerusalem and is mentioned in all of the Gospels.

The icon shows Christ and the Twelve Apostles gathered around a long rectangular draped table. In his left hand Christ holds a chalice of wine. His other hand is on the table and in the act of blessing a Eucharistic dish. The apostles are placed symmetrically in the vaults of the Gothic building which fills the background and on the two sides of the table. They are draped in a similar manner in chiton and himation. Their golden nimbi are inscribed with their monograms. They all appear to be surprised at Christ's remark that one of them will betray him. At the left side and sitting in the front, Judas is distinguished with a bag of money in his left hand and without a nimbus around his head.

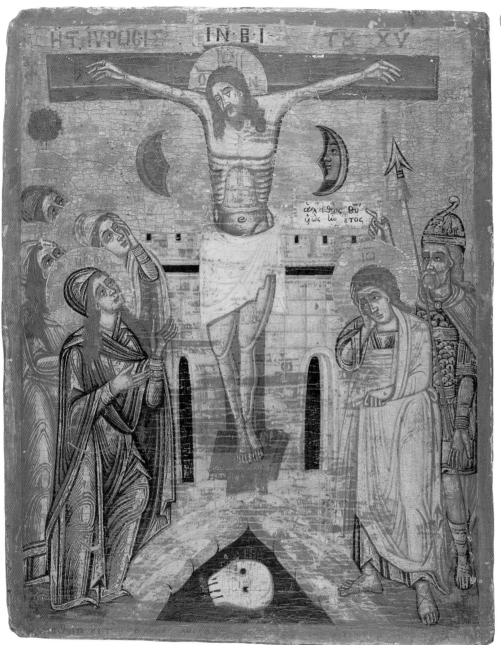

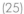

The Crucifixion (25)
Greek
Beginning of the nineteenth century
46,5 x 37
13730

The icon shows Christ on the cross with Jerusalem in the background.

In the sky the sun and the moon are veiled referring to the darkness (possibly an eclipse) which came over the whole land from the sixth to the ninth hour during the crucifixion.

Adam's skull in the dark cave which appears at the foot of the cross relates to Golgotha or Calvary, the site of the event outside Jerusalem.

On the left is the Virgin, behind her are Mary Magdalene, Mary Cleophas and another Holy Woman.

Opposite them is St John whom Christ charged with the care of his mother just before dying: behind him the centurion Longinus dressed in scale armour, helmet, and chlamys and holding a spear in his left hand. He points at Christ with his right hand exclaiming *He really was the Son of God!* (Mt 27:54).

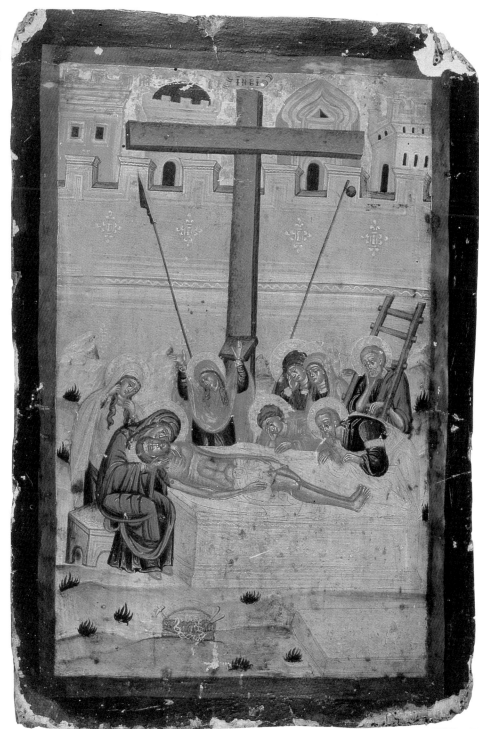

The Mourning (26)
Greek
Eighteenth century
44,5 x 30,5
13620

The body of Christ is being taken down from the cross and stretched out on a block of stone. Standing on the right, with his right hand raised to his face, Joseph of Arimathea, who has petitioned Pilate to allow the body to be removed from the cross; he holds the staircase he has used for lowering the body. Opposite him, the Virgin is seated on a stool and holds the head of Christ with both hands, and her cheek to her son's. Behind her and on the other side are the Holy Women with Mary Magdalene at the centre, her hands raised in wailing. St John bends forward, his left hand resting on the stone. Kneeling at the end is Nicodemus.

A basket containing the implements of the crucifixion, hammers, pincers and the Holy Nails pulled out by Nicodemus is shown on the ground in the front.

The background is filled with the instruments of the Passion — a spear, sponge and the cross — and the city of Jerusalem. The plaque on top of the cross, put there on the orders of Pilate, reads *INBI*, the initial letters of 'Jesus of Nazareth, King of the Jews' in Latin.

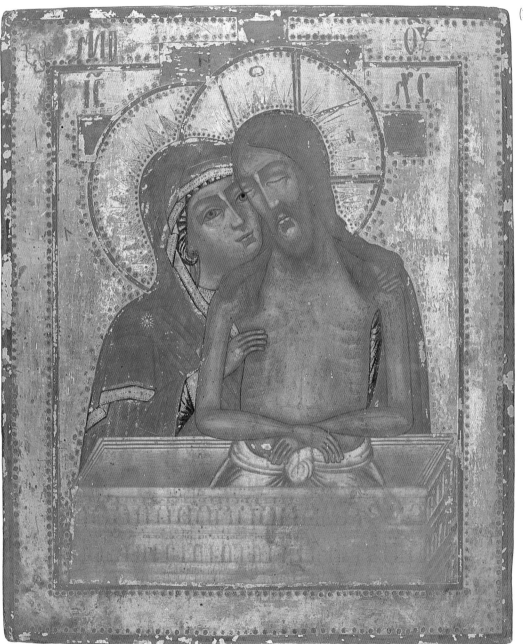

The King of Glory (27)
Russian
Nineteenth century
30 x 28
13180

The subject is also known as 'Weep Not For Me, Mother,' the title coming from canticle Nine of Matins for Holy Saturday, that is recited during the morning service on Holy Saturday, the day after Good Friday: 'Weep not for me, Mother, seeing in the sepulchre the son you conceived without seed in your womb — for I still rise and shall be glorified, and, as God, shall exalt those who praise you, with faith and love, in glory everlasting.' It has been suggested that the composition was inspired from this chant. Its Western equivalent is Pietâ, 'pity' or 'compassion.'

The icon shows the dead Christ in a chest to his waist. His head inclines to one side. His arms are crossed in front, his hands bearing the nail wounds. His mother holds and supports him.

Behind him are the arms of the cross, the top of the vertical arm bears the placard *INBI*.

The Ascension (28)
Russian
Beginning of the nine-
teenth century
44,5 x 36,5 13111

The Ascension of
Christ took place on the
fortieth day after his res-
urrection from the dead,
from the Mt of Olives,
in sight of his disciples.
During the event 'two
men dressed in white
garments suddenly
stood beside them' (Acts
1:10-11) and foretold
the impending Second
Coming of Christ.

The Virgin is repre-
sented in the centre,
flanked by the two an-
gels in light-coloured
robes and the Twelve
Apostles. She was not
present during the As-
cension: here, she rep-
resents the Church.
Above the group and
between the hills, the
footprints that Christ has
left are shown.

Christ is represented
suspended 'in glory' —
in an aureole borne by
flying angels blowing
trumpets.

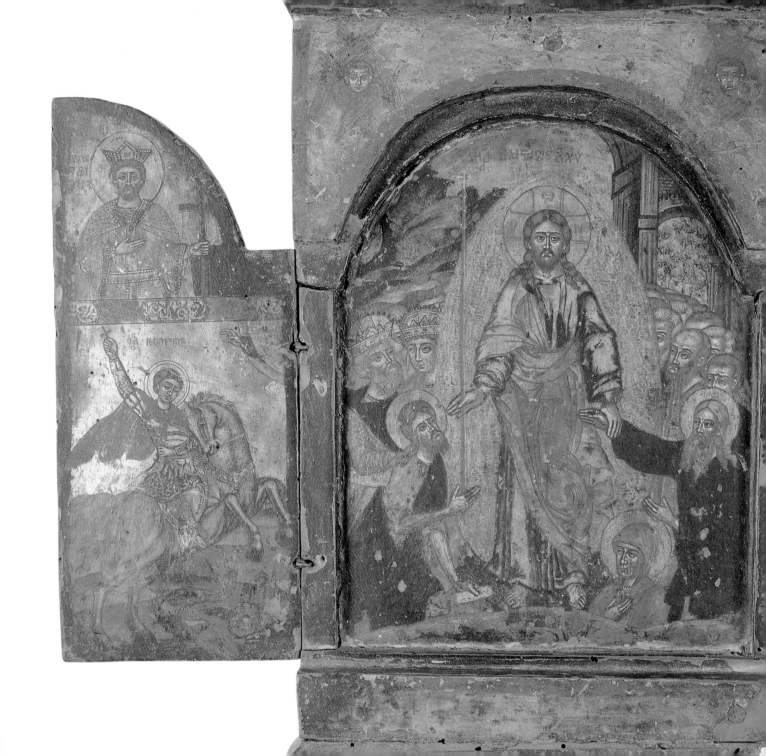

(29)

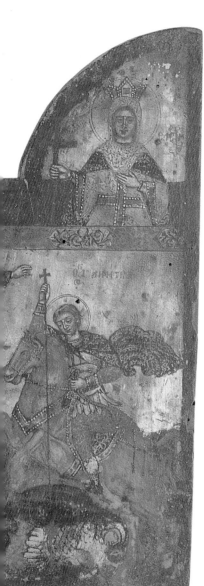

The Harrowing of Hell (29)
Greek
Seventeenth - Eighteenth centuries
33 x 44
13645

The inscription in Greek, *Anastasis,* which is inscribed above the head of Christ means the 'Harrowing of Hell,' or the 'Descent into Limbo.' After death, Christ descends into hell and brings out Adam and Eve, symbols of the righteous men and women of the Old Testament.

The essential elements of the story are represented on the large part of the triptych. At the centre is a figure of Christ drawn larger than the other figures; in his right hand he holds a long staff with a small cross on top. On this side is John the Baptist, who was sent to hell by Christ to announce his coming. His left hand holds a rolled scroll and the other is raised towards Christ in acclamation; he is draped in a skin cloak and a mantle. Above him are King David and his son King Solomon. With his left hand Christ raises Adam as a sign of the redemption of all righteous men. In front of Adam, Eve is shown. The scene is recessed in an arch. The spandrels are decorated with two winged angels.

On the upper register of the left leaf of the triptych are St Constantine (Constantine the Great) and below him St George in the act of killing the dragon. On the other wing are St Helena (the mother of Constantine the Great) and St Demetrios in the act of transfixing a pagan Roman soldier with a spear surmounted by a cross.

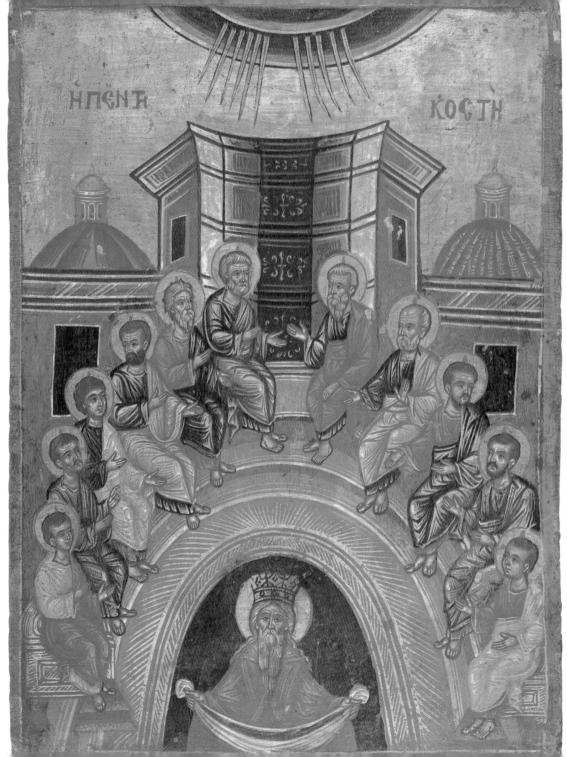

The Descent of the Holy Spirit (30)
Greek
Eighteenth century
46,5 x 34
13733

The inscription in Greek *Pentikosti* which is seen in two parts on the sides of the icon means 'the fiftieth (part).' In Jewish and Christian literature the word refers to the festival held fifty days after the Passover.

Originally Pentecost was a thanksgiving festival during which the first fruits of the wheat harvest were presented to Yahweh, and celebrated seven weeks after the beginning of the barley harvest, and thus known as the Feast of Weeks. In later Jewish tradition it was linked with the feast of the giving of the Tablets of Law to Moses on Mount Horeb (Sinai). During the event on the mountain, a voice was heard by Moses and it was divided into seven voices and these into seventy languages, so that all kinds of peoples heard it in their own tongues.

Scholars believe that the Christian tradition, which was first encountered in Luke, derives from ancient Judaism. According to this, the apostles were all together in the upper room of one of the houses of Jerusalem. Suddenly from heaven there came a sound like the rush of a violent wind, and it filled the entire house where they were sitting. A vision of tongues of flame spread out and each believer was touched by a tongue. They were filled with the Holy Spirit and began talking in various languages.

The icon shows eleven of the apostles — with Judas omitted — seated on a semicircular bench, with the youngest close to each end of the line. The Four Evangelists, distinguished by their white beards and hair, flank the empty central area reserved for Christ, the invisible Head of the Body. The drapery all of the figures consists of a long-sleeved chiton and a himation worn in a similar manner. Their heads and looks are directed at different spots.

The house in which they are meant to have gathered fills the background. This is a high building with a concave front having low horizontal wings with windows and domes with towers. Eleven thick red rays ending in tongues issue from the Holy Spirit in a segment of sky and fall on the apostles, a piece of ray resting on the head of each of them.

Below, in the black space — the darkness before Christianity — Cosmos, or the personification of the world as an old king holding a piece of cloth which contained the scrolls of the apostles, is shown.

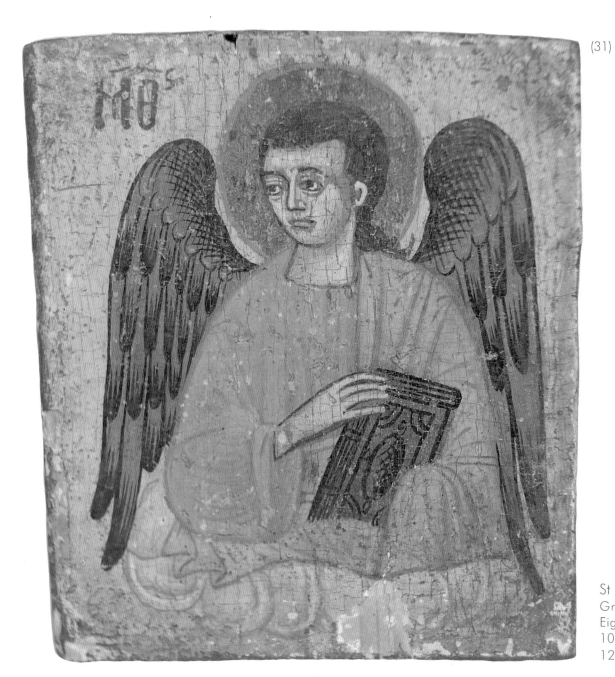

(31)

St Matthew (31)
Greek
Eighteenth century
10 x 11
12956

St Nicholas (32)
Russian
Nineteenth century
33,5 x 28
13143

St Nicholas, the fourth-century bishop of Myra in Lycia, Anatolia, is one of the most popular saints of the Eastern and Western Churches. His life was filled with lively exploits. He saved girls from prostitution by supplying them with dowries to get married; rescued sailors and brought to life murdered children. He is often represented standing full-length or half-length surrounded with saints or with scenes from his life.

The icon portrays the saint frontally and dressed in bishop's vestments. His right hand is raised against his chest and blesses. His other hand holds an open book of Gospels. Over his shoulders and on clouds, Christ and the Virgin are portrayed in blessing. The marginal representations belong to various saints.

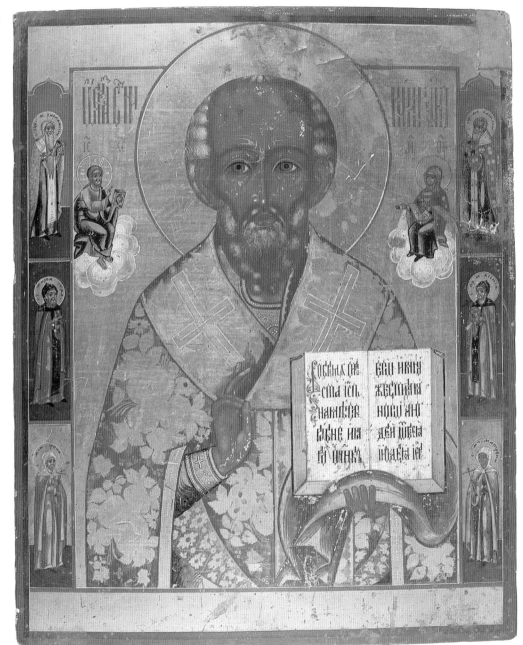

(32)

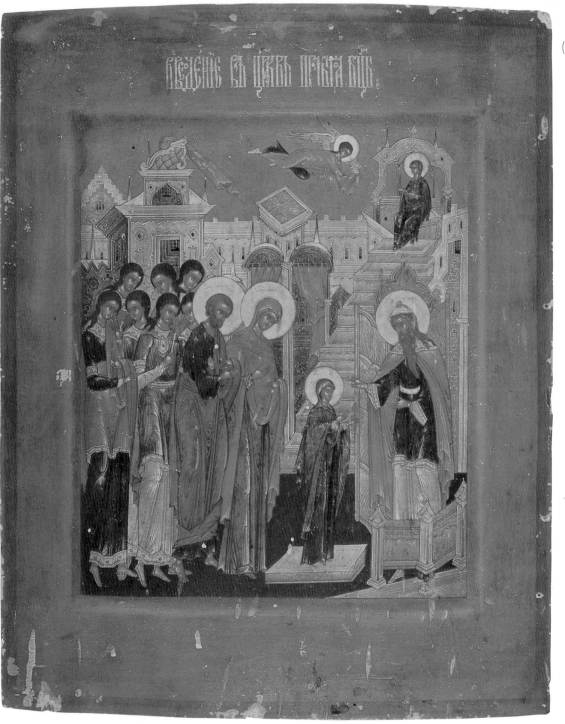

The Presentation of the Virgin in the Temple (33)
Russian
Beginning of the nineteenth century
44,5 x 36,5
13102

In accordance with their vow her parents took the Virgin to the Temple at Jerusalem.

The icon represents Joachim and Anne urging the child Virgin — who stands on a footstool — towards the high priest Zacharias, father of John the Baptist.

All of them have nimbi around their heads inscribed with their names. At the left are a group of the temple virgins, each carrying a lighted candle in one hand.

In the upper right corner is another incident from the Virgin's life in the temple — the Virgin receiving food from an angel.

Life-giving Spring (34)
Greek
1860
52,5 x 37
12963

The icon shows the healing water of the Pigi Monastery which stands in a grove just outside the city walls of Constantinople.

The monastery is said to have been founded in the fifth century by Leo I (457-74) and its water was regarded effective for physical and spiritual illnesses.

The icon shows the Virgin as the Mother of Christ whose birth gave immortality to mankind and as a spring whose waters healed mankind. She sits in heaven over the chalice of the fountain of the spring from which water falls. She is flanked by two angels standing in veneration and holding globes in their hands. Monks, bishops, royalties and afflicted are in the act of drinking or pouring the 'hagiasma' water on their heads.

On the upper right side the first discovery of the spring is described. Soldier Leo encounters a thirsty blind man and the Voice calls him strangely as 'Emperor Leo' and tells him that the spring he is looking for is within a grove outside the Golden Gate.

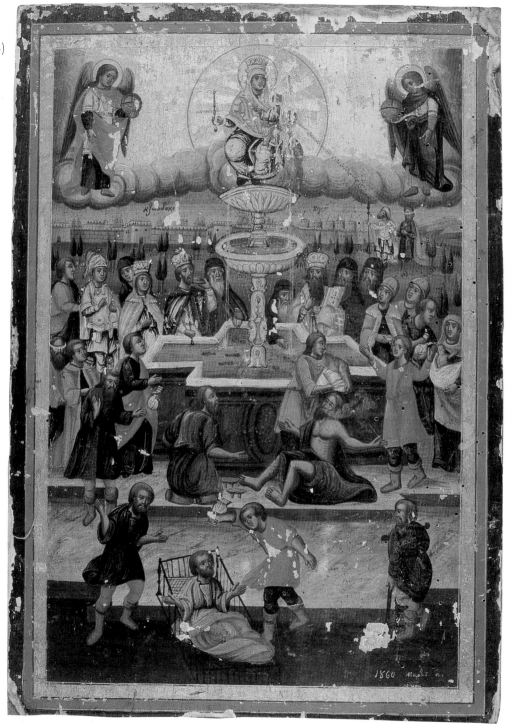

The Virgin and Child Surrounded by Prophets and Saints (35)
Greek
Eighteenth century
39 x 53
13617

In the central part of the triptych the Virgin is shown with the Child in a manner bringing to mind the 'Virgin Hodigitria,' the 'Virgin of the Way.' The latter stands on a rectangular stool and holds a globe in one hand and a staff in the other. The Virgin offers him a rose with her right hand. The theme is known as *Rhodon to amaronton*, 'the never fading rose'. On either side of the Virgin's head the sun and the moon are represented. Two angels bearing inscribed scrolls crown her as the Mother of God. She is surrounded by the figures of prophets.

At the top, God the Father is shown in heaven with the Holy Spirit in the form of a dove above the Virgin's crown. His right hand blesses. In the other hand he holds the globe.

The wings of the triptych show saints and prophets.

St John the Theologian (36)
Greek
Eighteenth century
22,5 X 17,5
12939

The icon shows St John seated and with his head turned towards the Word of God, represented as rays issuing from heaven. He is draped in a long-sleeved chiton over which a loose himation is worn. The right arm of his chiton is adorned with a gold band. His forehead shows the deep wrinkles of his age. His head is bald, his cheek-bones protruding. His right hand holds a quill pen. In the other hand he holds an open scroll already inscribed with the opening words of his Gospel: *In the beginning was the Word* (Jn 1:1). On a stand in the background are an ink-holder and quill pens.

While a later tradition holds that St John the Theologian, the 'Divine,' was martyred in Jerusalem at the same time as his brother James (the Greater), a contrary tradition claims that he took the Virgin, who was entrusted to him by Christ on the cross, with him to Asia Minor and lived at Ephesus.

At the time of the persecution of Domitian (AD 81-96) he was exiled to the island of Patmos where he wrote the book of Revelation, also known as the *Apocalypse*. The beginning of this book contains the letters addressed to the Seven Churches of Asia Minor. Tradition has it that following the death of Domitian St John returned to Ephesus, where he wrote the Fourth Gospel. He died during the reign of the Emperor Trajan (AD 98-117) reputedly at an advanced age of one hundred and twenty years. His sepulchre is in the church named after him on top of the hill of Ayasuluk[1] in the town of Selçuk near Ephesus. Christian tradition identifies him with St John the Evangelist and St John the Apostle.

[1] The Turkish name derives from the Greek *Ayios Theologos* and is thought to mean 'Holy Breath' or 'Aya Soluk' in Turkish.

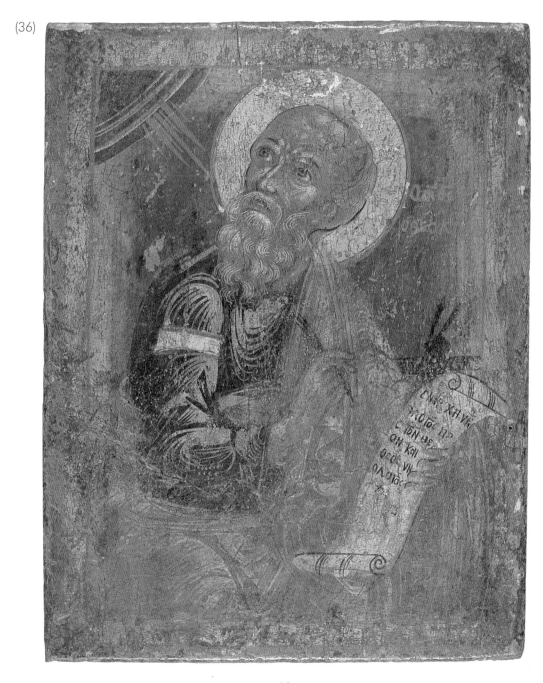

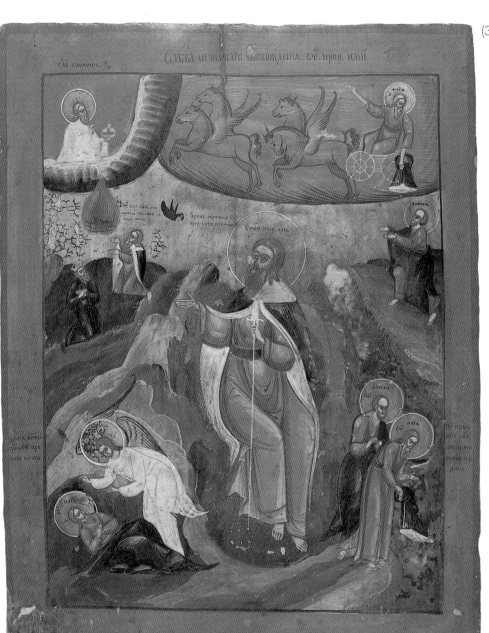

The Prophet Elijah (37)
Russian
Nineteenth century
39 x 30 13614

Elijah was a Hebrew prophet who is thought to have been active in the northern kingdom (Israel) in the first half of the ninth century BC. He is regarded as an Old Testament type of St John the Baptist.

At the centre of the icon he is shown being fed by a raven (1 Kgs 17:6).

In the upper left section, God sends down fire to burn the sacrifice that Elijah has prepared. In front of the prophet a kneeling figure with his hands crossed in front proclaims that 'the LORD alone is God!' (1 Kgs 18:38-39).

In the lower left corner, Elijah is sheltered from an earthquake and fire in a cave, where he was made aware of the presence of God in a small voice (1 Kgs 19:12).

In the lower right corner, he and his disciple Elisha cross the dry bed of river Jordan whose water Elijah parted by throwing down his cloak (2 Kgs 2:8).

In the upper right section, he is taken to heaven in a celestial quadriga moving obliquely upward and enveloped in an aureole of fire as he drops his cloak to his disciple Elisha thus bestowing on the latter the gift of prophecy (2 Kgs 2:11).

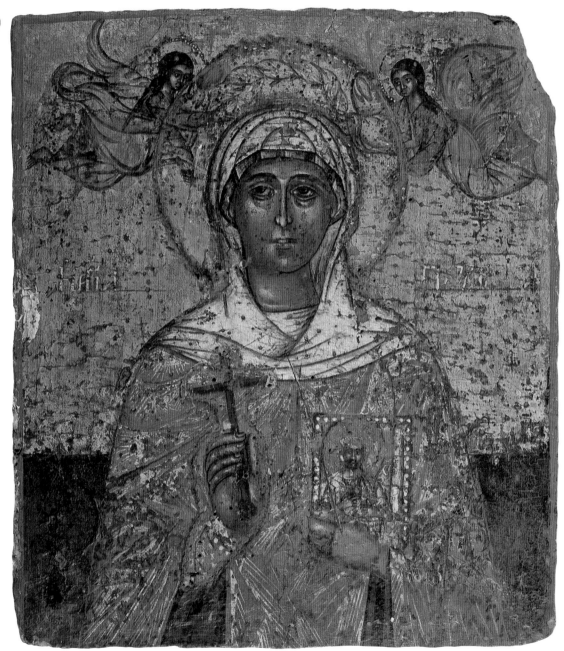

St Paraskeve (38)
Greek
Eighteenth century
27,5 x 24 13630

The icon represents one of the healer saints of the Eastern Christian tradition; Paras-keve who was born on Friday from which her name derives. She is mainly invoked for eye and ear problems and thought to have been martyred in the middle of the second century during the reign of Antoninus Pius (AD 138-61).

She is depicted half-length, standing and frontally. Her raised right hand holds a small cross. In her other hand is an icon of Christ surrounded with pearls.

She wears a dark coloured stole, shown only below her wrists, a red maphorion and a white veil which covers her capped head and falls on her shoulders.

Two flying angels are in the act of crowning her with a wreath.

(39)

The Holy Wonderworkers: Sts Cosmas and Damian (39)
Greek
Seventeenth - Eighteenth centuries
26,5 x 22
13646

Christian tradition has it that these twin Arabian physicians are thought to have come from Aegae (Ayaş), in Cilicia, and to have been brought up by their mother as Christians. During Diocletian's persecutions they were thrown into the sea and rescued by angels; cast into fire, but emerged unscorched. They were then stoned, but the stones rebounded, and so they were finally beheaded at Cyrrhus in Syria in AD 287. Their bodies were taken to Rome where a church was dedicated to them in the sixth century.

The cult of Sts Cosmas and Damian became very popular from the fifth century onwards, owing to their medical and surgical skill and their refusal to accept fees which caused them to be called *anargyri*, 'silverless' or 'the holy moneyless ones.' On one occasion they are said to have even replaced a man's diseased leg with one from a black man who had just died. When he awoke, to his amazement the patient saw that he had one black and one white leg.

It is also claimed that they were a Christianized form of the Dioscuri, the twin sons of Zeus. Their treatment also included the 'incubation,' the pagan method cure of the healer-god Asclepius in which a sick person slept in the temple, hoping to be favoured with a dream that would lead to his cure.

The saints carry long cylindrical boxes containing the instruments of their professions. St Cosmas also holds a medical instrument in his right hand. Their facial features and hair style are similar; their skin is rendered in copper-brown colour. Their drapery consists of a long and a shorter tunic with sleeves over which a loose mantle is thrown. Between the saints and above their heads Christ is represented sitting in heaven and blessing them with both hands.

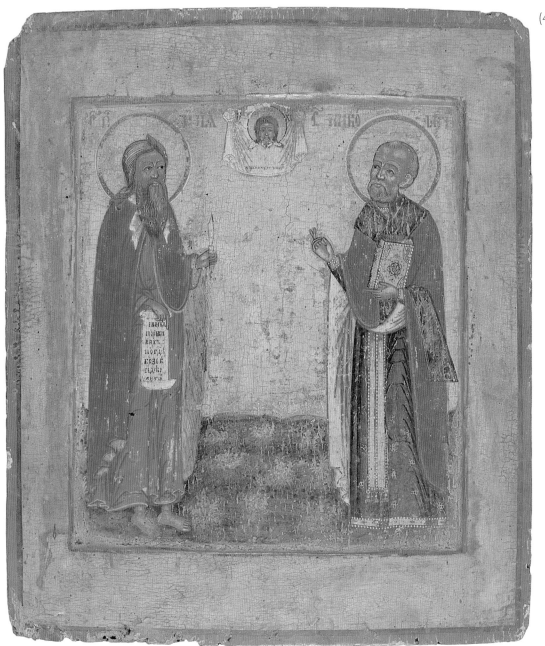

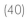

(40)

Sts Charalambos and
Nicholas (40)
Russian
Eighteenth century
31 x 27
13172

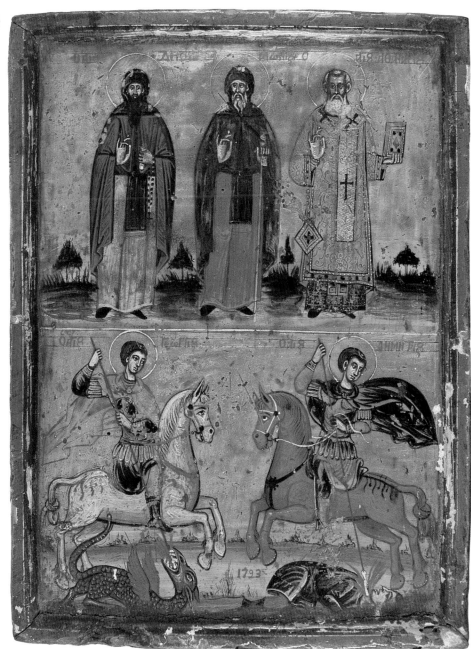

(41)

Sts Dionysius, Andonias, Athanasius,
George and Demetrius (41)
Greek
1793
28 x 21
13774

The Forty Martyrs of Sebaste
(42)
Greek
Seventeenth - Eighteenth
centuries
26,5 x 22
13646

Tradition has it that forty soldiers of a Roman legion stationed in Sebaste (Sivas, in Turkey) who had accepted Christianity, refused the command of the Emperor Licinius to abandon their faith in AD 320. They were forced to spend the night on a frozen lake.

At the centre the martyrs are shown naked, partly submerged into the lake of ice. Those who were not dead by the next morning were killed and their remains burned.

On the right with smoke rising from it is a hot bath, intended as an extra inducement of apostasy. There is a soldier in front of it. One of the naked figures has stepped forward to the bath, thus abandoning his faith.

Above, Christ stands on clouds and beneath him are the forty crowns of martyrdom (with one cancellation) descending in glory.

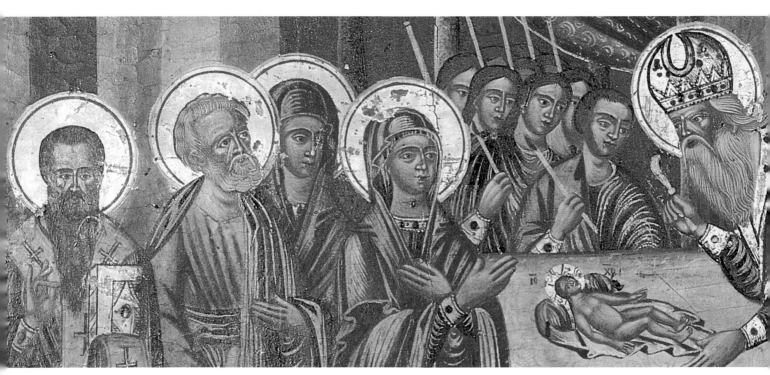

The Circumcision (47). Detail. The Antalya Archaeological Museum.

ICONS from the
ANTALYA
ARCHAEOLOGICAL MUSEUM

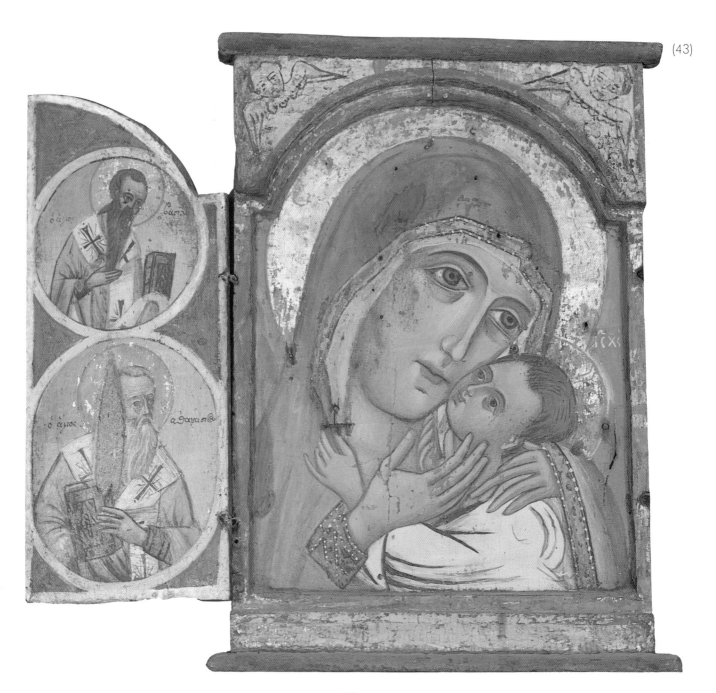

The Virgin of Tenderness (43)
Greek
Nineteenth century
31,5 x 24
32.2.82

(44)

 In the Russion iconography this type is known by its most popular name as the Virgin of Korsun (Cherson) on the Black Sea. The original is thought to have been carried from the town to Kiev by the Great Prince Vladimir in 988.

The Annunciation to the Virgin (44)
Greek
Nineteenth century
131 x 72,5
3.2.82

 The event is expected to be imagined taking place in the building shown in the background. The Virgin is dressed in rich robes of golden weft. She looks at the open book in front of her. Her arms are raised in a gesture of acclamation. The inscription on the left side in Greek, reads *Annunciation of the Mother of God*. Opposite her and on a cloud stands the Archangel Gabriel. He brings her the news of the coming birth of Jesus Christ, proclaiming the secret of the Divine Incarnation. While blessing with his raised right hand, with the other extended hand he offers the Virgin a blossoming branch, the symbol of her virgin conception. Heavenly rays descend and the Holy Spirit shown as a dove falls towards her. The all-seeing eye of God is shown in a triangle above. A dedicatory inscription fills the left corner of the icon.

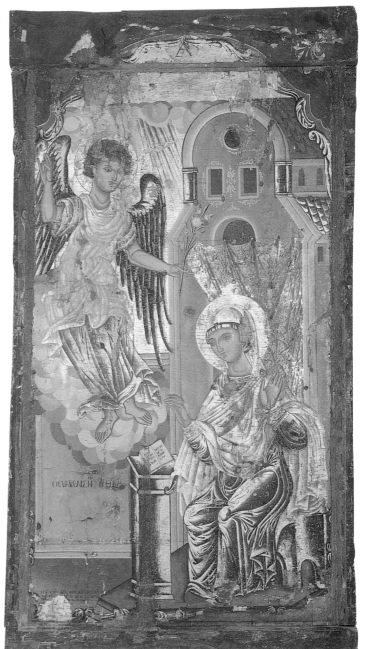

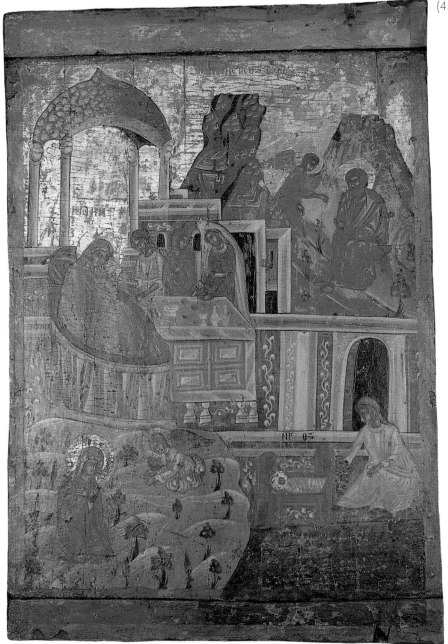

The Birth of the Virgin (45)
Greek
Nineteenth century
53,5 x 37,5
151.2.82

The lower left section shows Anne praying in a conventional landscape of hills and scattered trees. An angel, presumably the Archangel Gabriel, bringing her the answer to her prayers, approaches from the right holding a palm branch in his left hand. The upper right section shows her husband Joachim sitting in rocky landscape. An angel brings him the good tidings.

In the upper left section Anne is shown seated on a couch. In front of her is a table with various sorts of vessels. Three women stand at her table. The first one on the left, who looks like a servant offers her a cup. The second, looks and points to the left. The third, dressed like a bride places a present on the table. The architectural background is shown as a structure with a canopy symbolizing the Temple. The infant Virgin is represented in a cradle, attended by a woman.

The Presentation in the Temple (46)
Greek
Nineteenth century
41,5 x 31 124.2.82

Luke (2:22-28; 36-38) relates that 'When the days were completed for their purification according to the law of Moses, they took him up to Jerusalem to present him to the Lord...'

'Now there was a man in Jerusalem whose name was Simeon. This man was righteous and devout, awaiting the consolation of Israel, and the Holy Spirit was upon him. It had been revealed to him by the Holy Spirit that he should not see death before he had seen the Messiah of the Lord. He came in the Spirit into the temple; and when the parents brought in the child Jesus to perfom the custom of the law in regard to him, he took him into his arms and blessed...'

'There was also a prophetess, Anna... And coming forward at that very time, she gave thanks to God and spoke about the child to all who were awaiting the redemption of Jerusalem.'

Simeon is shown standing at the door of the Temple. He is bent forward reverently with piece of cloth on his extended arms, ready to receive the Child. The Virgin hands him the infant Christ. Her companion is the aged prophetess Anna. She holds an unfurled scroll which reads, *This Child has made heaven and earth secure*. Joseph follows them with two sacrificial turtle doves in accordance with the Mosaic law.

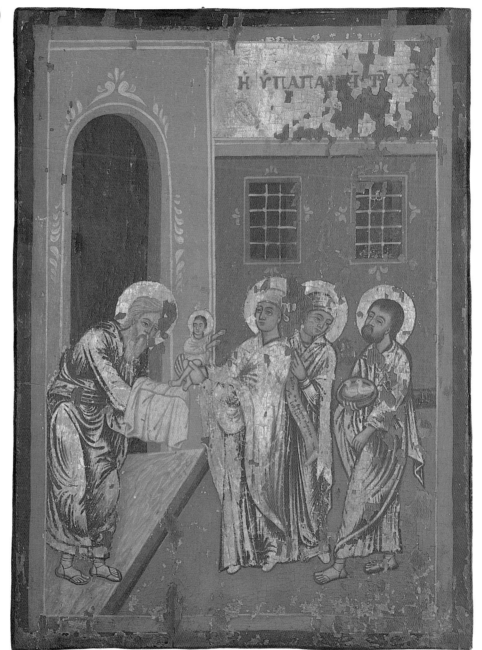

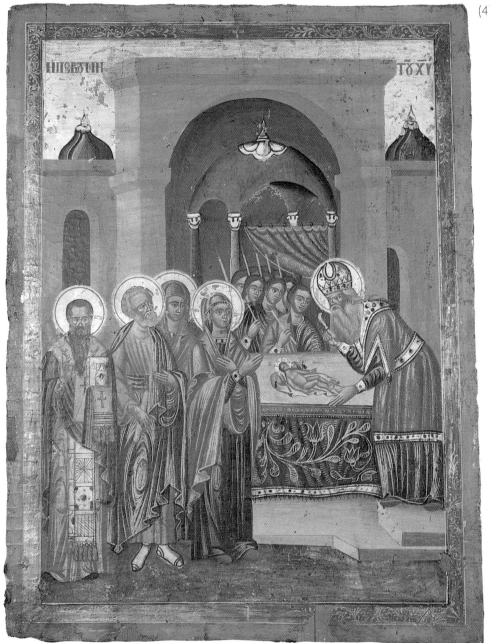

The Circumcision (47)
Greek
Nineteenth century
55,7 x 42,2
163.2.82

This icon shows Christ's circumcision in the Temple, identified by the altar canopy supported by four columns. The infant Christ lies on a draped table next to which is a group of temple virgins. Both his hands are in the act of blessing.

On the right is a ritual surgeon (*mohel*), dressed in Jewish priestly garments; he holds a knife in his right hand and bends towards the infant. The knife and the foreskin of Christ were regarded as Holy Relics.

On the left, four nimbed figures stand and watch. The Virgin has crossed hands and behind her is another Holy Woman. Joseph, the earthly father of Christ holds a rolled scroll in his right hand. The last figure wearing a bishop's vestments, blesses with his right hand and holds a book of Gospels in the other.

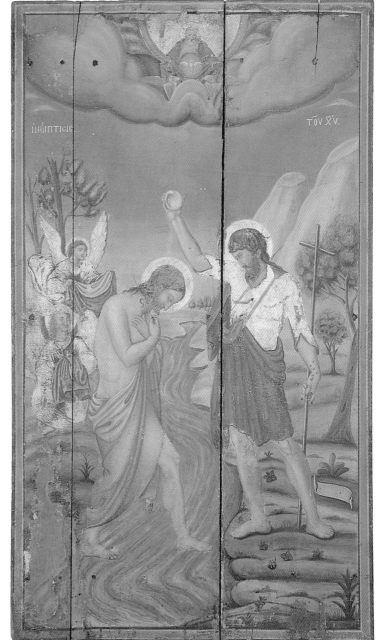

The Baptism (48)
Greek
Nineteenth century
128 x 75
2.2.82

The baptism of Christ in the Jordan is related in all of the four Gospels of the New Testament. Christ stands on the water. His nimbed head is bent forward. Behind him are shown two angels holding pieces of clothes in an act of veneration, not Christ's clothes as popularly supposed.

On the right bank of the river, John the Baptist pours water from a seashell over Christ. John wears animal skins held by a strap over his chest. He holds a cruciform staff and next to his left foot is an open scroll.

In the form of a dove the Holy Spirit descends from heaven where sits God the Father in an aureole supported by two angels. He is depicted as an old man with white hair and a long white beard.

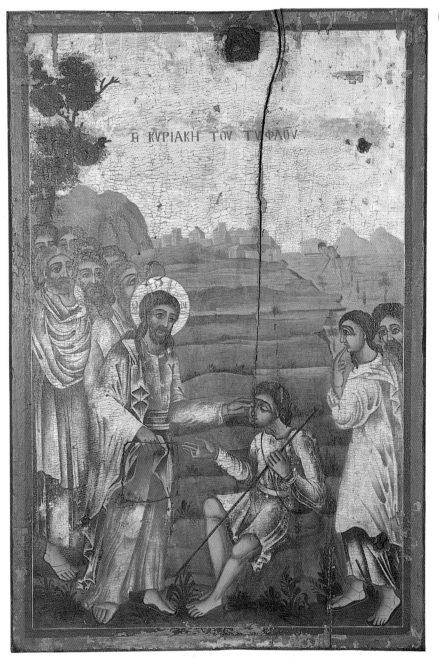

(49)

The Healing of a Blind Man (49)

Greek

Nineteenth century

57 x 38

144.2.82

The healing of the blind man or two blind men, which took place outside Jericho is recounted in the Gospels (Mk 10:46-52; Lk 18: 35-43; Mt 20:29-34). In one variant the blind man sits by the road begging, in another he stands before Christ, recognizing him by calling out to the Messiah to have mercy on himself. He is named Bartimaeus only in the Gospel of Mark.

In the icon, Christ touches the eyes of a blind man with his left hand, probably rubbing the mud that he made with his saliva (Jn 9:1-12) on the man's eyes. This act on someone born blind alludes to the idea that not only the eyes but the whole person is being opened. His head is adorned with an inscribed cruciform nimbus. His right hand holds the hem of his mantle. He is followed by a group of his disciples.

The blind man is shown seated on the ground. His open right hand is extended towards Christ. In his other hand he holds a long staff. He is dressed in a simple tunic and a rectangular beggar's pouch hangs from his shoulder. On the right are witnesses of the miracle showing their surprise.

In the distance, a cripple with a walking stick and closed eyes, perhaps to indicate blindness, emerges from a town.

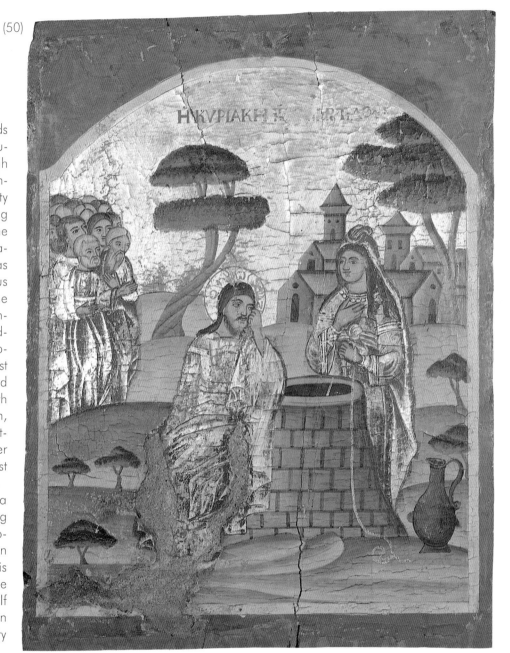

(50)

The Samaritan Woman (50)
Greek
Nineteenth century
55 x 42 20.2.82

Christian literature (Jn 4:1-30) holds that when Christ travelled from Judea to Galilee, he had to go through Samaria, a region inhabited by other people than Jews. Outside the city of Sychar he sat down by the spring called Jacob's well. A woman came to the well with a pitcher to draw water and he asked for a drink. She was astonished that an apparently pious Rabbi, and probably a Pharisee should speak to a Samaritan woman, the Samaritans being not regarded as a real Jews. She is usually represented as a prostitute because Christ revealed to her that he knew she had had five husbands and was living with a sixth man. In a long conversation, Christ told her that he was the expected Messiah, that he would give her the water of eternal life and God must be worshipped in spirit and in truth.

Christ is represented seated on a rock by the well with his elbow resting on the wall of the well and hand supporting his head. The Samaritan woman stands opposite him. She is clad in the costume of a bride. She raises one hand and points at herself and holds the rope of the bucket in the other. In the background is the city of Sychar (Shechem).

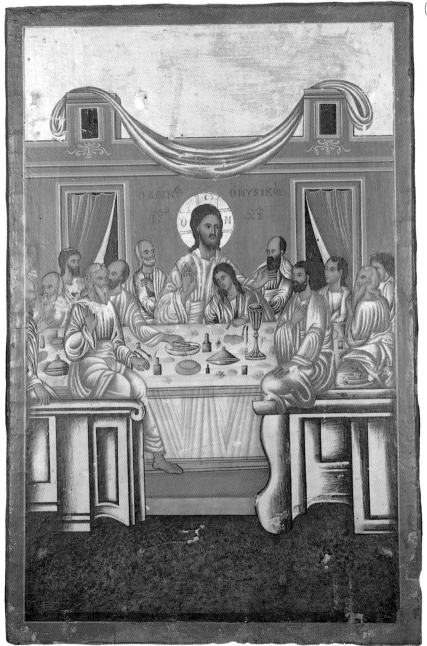

The Last Supper (51)
Greek
Nineteenth century
56,5 x 38
147.2.82

Christ and the Twelve Apostles are shown seated in a relaxed manner around a covered table laid with the customary vessels of the ritual: a chalice of wine, smaller cups, forks, knives, a loaf of bread and a piece of bread in front of each apostle, and a large plate full of fish, the early Christian symbol of Christ. They are in a house in Jerusalem in 'a large upper room and ready' (Mk 14:15).

Christ is larger than the other figures. His head is adorned with a cruciform nimbus. He is turned slightly to the left, his open left hand extended. His other hand is raised in blessing. The apostles are represented in the act of denying his accusation that one of them would betray him. Judas is identified by his act of reaching into the dish of fish. 'One of his disciples, the one whom Jesus loved, was reclining at Jesus's side' shows a handsome young man with his long hair falling on his shoulders who would remark 'Master, who is it?' (Jn 13:23-25).

In the background a building is shown symmetrically with a long cloth thrown across its towers in Byzantine fashion.

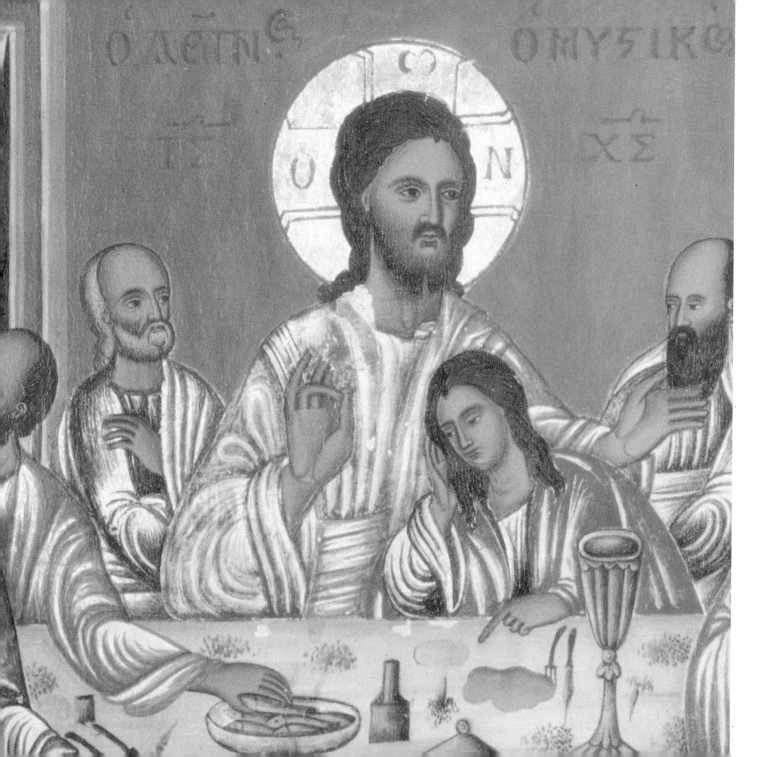

(52)

The Entry into
Jerusalem (52)
Greek
Nineteenth century
58 x 45,5
7.2.82

The icon shows Christ's entry into Jerusalem.

He rides a white ass and is seated on the animal sideways, facing the worshipper. His right hand is raised as he blesses the crowd who meet him. He is followed by his apostles. In the background is the Mt of Olives.

People have come out of Jerusalem to greet him with palm branches. A child has taken off his garment and is laying it before Christ's ass. In his right hand he holds a palm flower. Another child has climbed a tree and is cutting and throwing branches on Christ's path. His back is turned to the onlooker and he is precariously dangling from the tree. The presence of children is not mentioned in the accounts of the New Testament but derives from the apochryphal Gospel of Nicodemus. The spandrels of the arch are adorned with winged angels.

The Washing of the Disciples' Feet (53)
Greek
Nineteenth century
56 x 42
28.2.82

The Gospel of John (13:1-20) has it that Christ made this act of ablution in the same house in which the Last Supper would take place.

Christ is represented in three-quarter view, turned towards the line of disciples. A towel hangs from his waist. His head, which is adorned with an inscribed cruciform nimbus, is turned towards the worshipper. His hands are extended towards the foot of Peter placed in the bowl with water. The latter at first objected to his Master's act because at the time the washing of feet was usually done by servants; however, when the purpose was explained to him, that he was giving an example, that they should do as he has done to them, exclaimed 'Master, then not only my feet, but my hands and head as well.'

In the icon Peter is shown pointing at his head with the raised right hand. Behind, the other disciples are getting prepared for the same ritual.

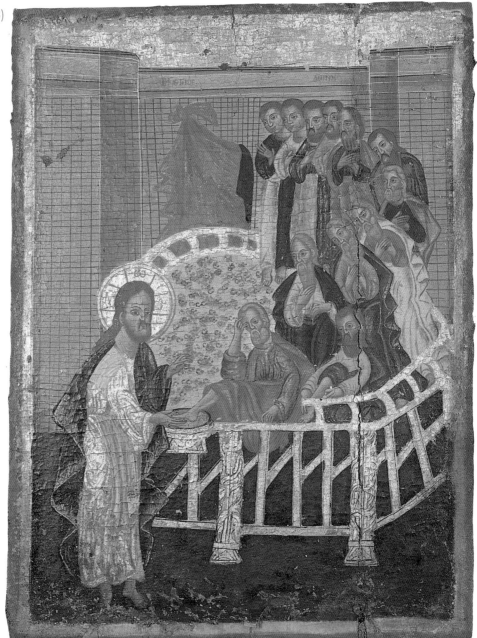

(53)

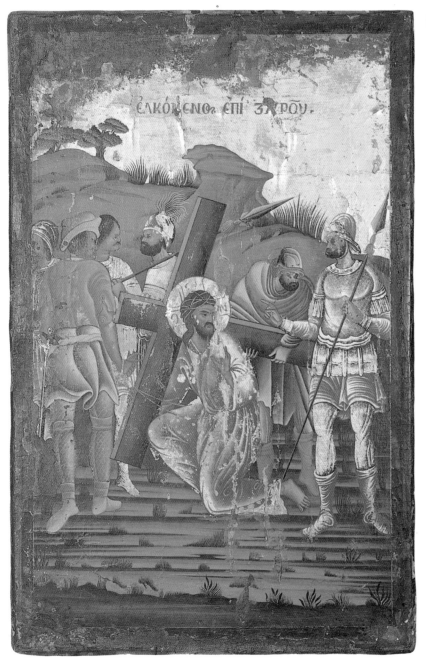

(54)

The Way to Golgotha (54)
Greek
Nineteenth century
56 x 36,5
148.2.82

At the centre of the icon Christ is shown with one knee on the ground, his head turned backwards. He wears the crown of thorns. The rope which is tied at his waist is pulled by a soldier shown from back and with his head in profile. Christ is dressed in a garment 'seamless, woven in one piece, from the top down' (Jn 19:23). On the right another soldier is shown in armour and holding a spear in his left hand and pointing at Christ with the other. On the other side of the cross, Simon of Cyrene whom the soldiers had met on the way and forced to carry the cross, is shown trying to raise it with both hands. Luke (23:26) recounts: 'As they led him away they took hold of a certain Simon, a Cyrenian, who was coming in from the country; and after laying the cross on him, they made him carry it behind Jesus.' The story is also told in Matthew (27:32). Three more soldiers are shown on Christ's right.

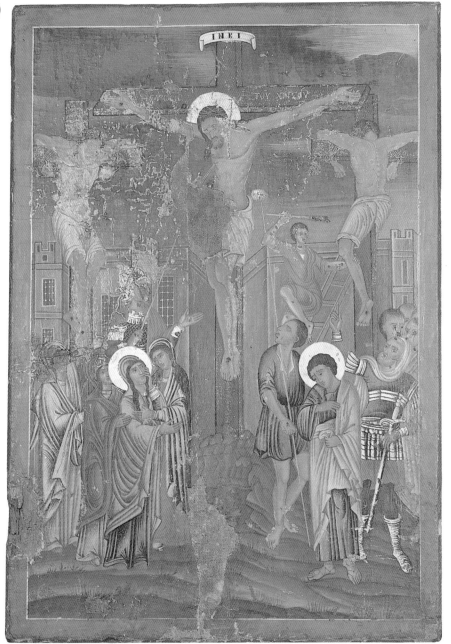

(55)

The Crucifixion (55)
Greek
Nineteenth century
55,5 x 39
150.2.82

 The event is shown taking place in front of the walls of Jerusalem. Above Jesus's head is a scroll with the word *INBI*, the initials of 'Jesus of Nazareth, the King of the Jews' in Latin, put there at the order of Pilate. Christ wears the crown of thorns.

 The Virgin, distinguished by the nimbus around her head, stands in front of a group of Holy Women. Behind them is the centurion Longinus who has pierced Christ's side with a lance; on the other side is his companion Stephaton. Blood and water pour from the wound of Christ, so that Adam, whose skull is represented in the cave at the foot of the cross, could be baptised by the water and redeemed by the blood of Christ.

 On the left side of the cross St John is shown. His nimbed head is bent on his right shoulder in grief. Behind him is the figure who put a sponge soaked with wine on a stalk of 'hyssop[1] and put it up to his mouth' (Jn 19:29). The good and bad thieves, hung on either side, are on crosses lower than that of Christ. The bad thief is shown backwards. A man who seems to have finished nailing him descends the ladder.

[1] A plant with diuretic powers, that therefore symbolized forgiveness of sins to those who truly repent.

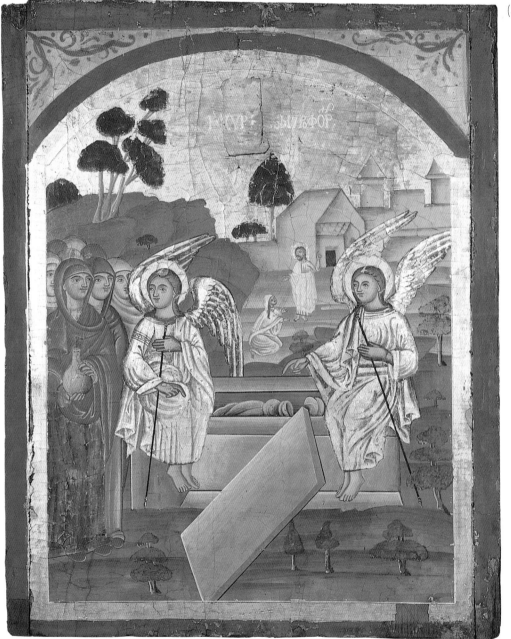

The Empty Tomb (56)
Greek
Nineteenth century
56,5 x 45,5 50.2.82

This event is told in all of the four books of the Gospels varying only in detail. In the icon the Holy Women, Mary Magdalene, Mary the mother of James and Mary Salome (or Joanna) and others according to the Gospel of Luke, are represented on the left side of the Empty Tomb which is shown as a rectangular chest with its lid fallen to one side. The angels who opened the tomb are depicted with spread wings and holding long staffs in their left hands. They are seated on the corners of the chest and point at the empty grave. In the tomb is the Holy Shroud, the linen clothes in which the body had been wrapped and the cloth that had been over Christ's head.

In the background the scene where Christ appears to Mary Magdalene (Jn 20:14) is represen-ted. Christ is shown standing. His palms bear the nail wounds. His right hand is extended to the young woman who has kneeled down on the ground with her hands extended in the act of adoration. With his left hand Christ points at the sky.

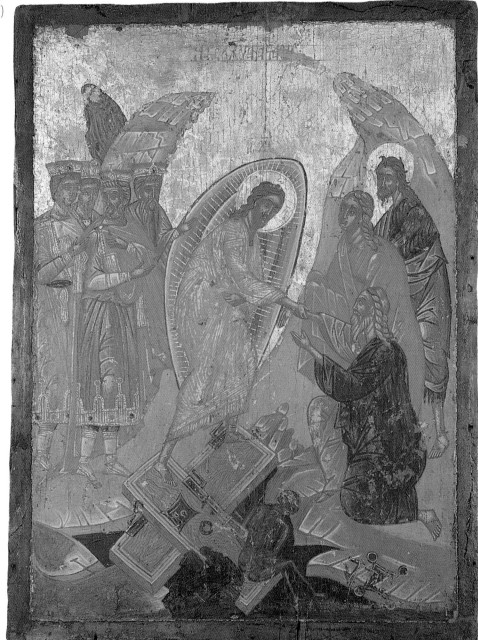

The Harrowing of Hell (57)
Greek
Nineteenth century
48,5 x 36,5
34.2.82

At the centre is Christ in a mandorla of two zones with rays from his body. His golden cruciform nimbus is inscribed with his name. His left hand holds a rolled scroll as the symbol of the Word. With his other hand he holds Adam by the right wrist, raising him from death. There is no grave. Behind Adam are Eve, with her hands raised in her loose mantle waiting to be saved and John the Baptist in his conventional attire of a skin cloak and mantle and who has entered hell before Christ to announce his arrival.

Opposite them on the other side are King David, his son King Solomon and two more figures of Christ's ancestry. Under Christ's feet are the two leaves of the broken gates of hell with hinges and handles. Satan is shown with his wrists bound behind him and joined to an iron band around his neck.

The Triumph of Orthodoxy (58)
Greek
Nineteenth century
48 x 34
5.2.82

The Triumph of Orthodoxy refers to the Restoration of the Holy Images in 843, at the end of the Iconoclasm. It is a feast icon for the Sunday of Orthodoxy, the first Sunday in Lent.

In the upper register it shows the famous icons among which those of the Holy Cloth and the Virgin of the Way are easily distinguished. In front of the iconostasis are the important personages of the time of the official ending of the Iconoclasm. At the right, the regent Empress Theodora holds an icon of the Virgin of Tenderness. On her right her young son, the Emperor Michael III stands. The figure opposite her must be the Patriarch Methodius (in office 843-47), holding a staff in one hand and the book containing the true doctrine in the other.

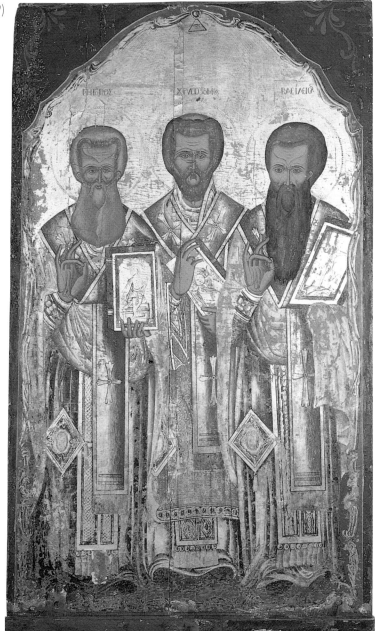

The Holy Hierarchs: Sts Gregory the Theologian, John Chrysostom and Basil the Great (59)
Greek
Nineteenth century
125 x 73,5
18.2.82

The three Church Fathers are identified by the inscriptions above their heads. They are from left to right St Gregory the Theologian of Nazianzus (AD 329-89),St John Chrysostom (AD 347-404) and St Basil the Great (AD 329-80). Their stance and attire are almost identical and all are bareheaded. The right hand is against the chest, blessing in the manner of the Eastern Orthodox Church, the third finger touching the thumb. The hand of St Chrysostom is shown turned inward and as usual he has a small beard. In the left hand each figure holds a book of Gospels. The left hand of St Basil is hidden in the folds of his pink mantle. The long, pointed black beard characterizes him.

They all wear sumptuous liturgical vestments: tunic (*sticharion*) falling to the feet, gold embroidered stole (*epitrachelion*), a sleeveless mantle (phailonion) and a bishop's omophorion bearing crosses. They have embroidered sleevelets (*epimanikia*). From the belt of each hangs a lozenge-shaped ornament (*epigonation*).

From the All-seeing eye of God, enclosed within a triangle, rays of light descend on them.

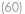

The Revelation of St John the Theologian (60)
Greek
Nineteenth century
131 x 77
38.2.82

Christian tradition identifies St John the Theologian, also known as St John of Patmos, with St John the Evangelist and St John the Apostle. He is represented seated on the rocks in front of a cave on the island of Patmos to which he was exiled by the Roman Emperor Domitian (AD 81-96) for preaching the Gospel in Ephesus or refusing to worship the imperial cult. He wears a voluminous chiton and himation, and is shown as an aged man with an open forehead and a great long beard. He leans his head on his left hand. His other hand holds a book of Gospels. Behind his right shoulder is his attribute, the eagle.

In front of him is the very small figure of his young disciple and scribe Prochorus, recording the book of Revelation on a scroll. He sits on a stool and writes on a small table with a quill pen. The inscription refers to the figure of the woman and the beast represented on the right: 'a woman, clothed with the sun, with the moon under her feet, and on her head a crown of twelve stars' (Rv 12:1). She is thought to represent the pregnant Virgin and also the Church, with the twelve stars on her head symbolizing the twelve tribes of Israel from whom the Messiah comes. Thought to symbolize the Roman Empire is 'The dragon with seven heads which with his tail dragged a third of stars of the sky and threw them down to the earth. He stood in front of woman in order to eat her child as soon as it was born' (Rv 12:3-5).

God the Father is shown blessing with both hands from heaven. Rays of light descend on St John's head.

St Charalambos (61)

Greek
Nineteenth century
126,4 x 75
162.2.82

St Charalambos is one of the popular figures of the Greek Orthodox tradition. He is said to have served as the bishop of Magnesia in Thessaly and was beheaded during the reign of Septimius Severus (AD 193-210) when he refused to turn from his Christian faith.

The icon represents him frontally, standing and draped in priestly garments. His right hand is raised in blessing; his other hand holds a book of Gospels. In the upper left corner is Christ in heaven, one hand blessing and the other holding a globe. In the opposite corner a flying angel brings a crown. Rays of light issue from the All-seeing eye of God.

At the bottom the figure is flanked by miniature representations.

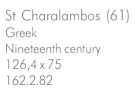

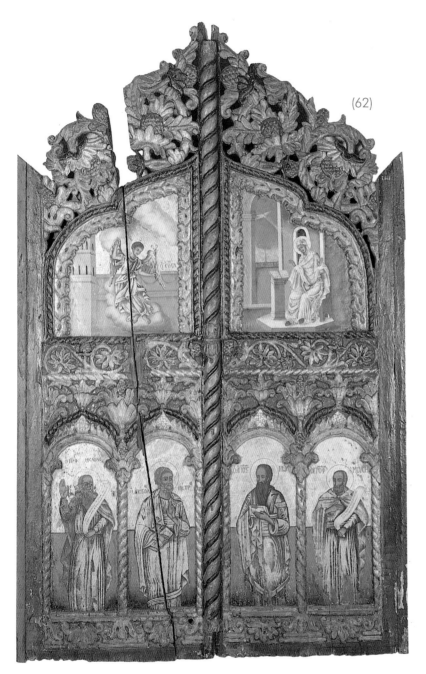

(62)

Royal Doors (62)
Greek
Nineteenth century
146 x 93,5
107.2.82

In the Orthodox churches the central doors of the iconostasis which give direct access to the sanctuary where the altar was kept were known as the Holy or Royal Doors. In the fourteenth century with the introduction of the tradition of hanging icons on the iconostasis, along with the rectangular or square icons, icons executed in the shape of the Royal Doors began to be produced. In such icons, often the Annunciation or the Last Supper occupied the upper central register. The compartments of the lower register were decorated with the pictures of the evangelists which, until then, occupied the squinches or pendentives of the dome; alternatively, there were saints or bishops, which occupied secondary surfaces.

On the right side of the upper register sits the Virgin with hands open acknowledging the message brought to her. Her virginal conception is rendered by a ray of light entering through the window. Opposite her and on the left, standing on a cloud, is the Archangel Gabriel, identified by an inscription. He is seen blessing with the right hand and offering the Virgin flowers with the other.

The lower register is divided into four niches. From left to right the standing figures are identified as the prophet Isaiah, St Peter, St Paul and the prophet Moses. The scenes are inset in frames decorated with relief carving.

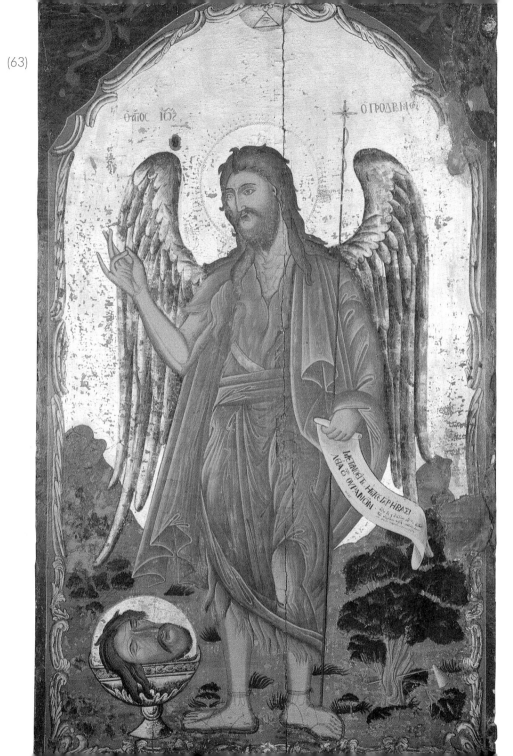

(63)

Θ ΆΓΟς ΙΩ̅ς Ο ΓΡΟΔΡΜΦ

St John in the Wilderness (63)
Greek
Nineteenth century
131 x 74
19.2.82

The Annunciation to the Virgin (67). Detail. The Sinop Museum.

ICONS
from the
SİNOP MUSEUM

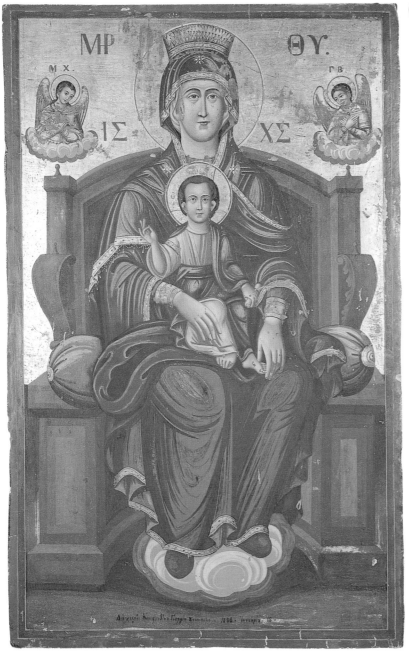

The Virgin Enthroned with Child (64)
Greek
1886
91 x 58
13.115.70

The inscription on either side presents the Virgin as Theotokos, the 'Mother of God'. She sits on a wooden throne, turned slightly to her left. She wears a blue stole which falls to her feet, the cuffs and hem worked with gold bands. Her crowned head and the upper part of her body is wrapped in a maphorion. Gold ornaments in the shape of stars decorate the centre of the hood over her head and shoulders. Her white cap is visible behind her ears. She sits on a thick purple-coloured cushion whose cylindrical ends are decorated with concentric gold bands. Her feet rest on a footstool of clouds.

The Child sits on the Virgin's lap. His right hand is raised and blesses in the manner of the Orthodox Eastern Church, the top of the third finger touching the thumb. His other hand which holds a scroll rests on his left thigh. His nimbed head belongs to a youth, a characteristic of Byzantine art showing him endowed with miraculous attributes. He wears a light blue chiton and a red himation.

Above the throne and on either side the archangels Michael (left) and Gabriel (right) sit on clouds in adoration of the Child-God.

The inscription at the bottom indicates that the icon was made by Constantinus, son of Georgius of Sinop, January 18, 1886.

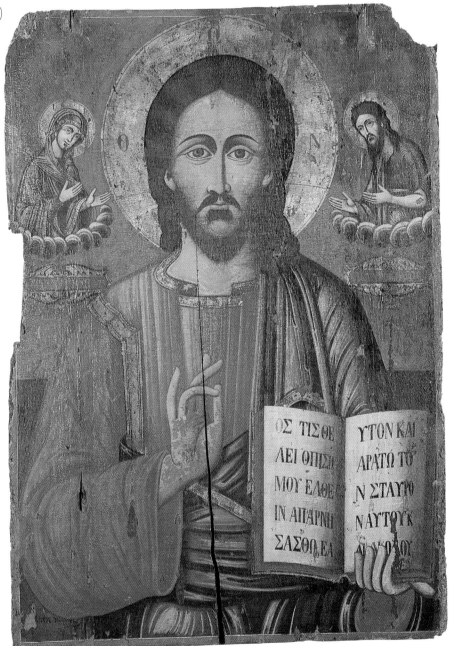

Christ Pantocrator (65)
Greek
Nineteenth century
78 x 59
13.128.70

Christ Pantocrator, the 'Lord of the Universe' is represented half-length, frontally and standing and looking beyond the worshipper. He is bearded and long haired. He wears a red chiton over which is a blue-purple himation. Both garments are decorated with gold bands.

His right hand is against his chest in blessing in the manner of the Orthodox Eastern Church. His other hand holds an open book of Gospels. The inscription in Greek, reads, *If anyone wishes to come after me, he must deny himself and take up his cross daily and follow me* (Lk 9:23). His head is adorned with a inscribed cruciform gold nimbus which divides the inscription *Jesus Christ* into two. Next to his shoulders there are baroque medallions which bear the monogram of his epithet.

On either side are busts of the Virgin and St John the Baptist placed on clouds. They are turned towards Christ, their heads bowed, their open hands extended imploring the salvation of mankind as in a composition of the Deisis.

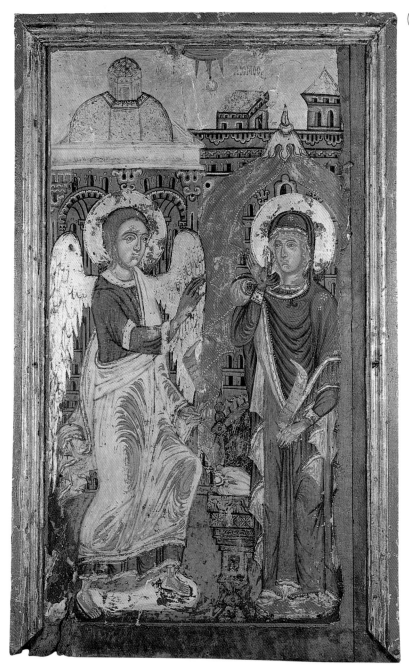

The Annunciation to the Virgin (66)
Greek
Nineteenth century
105 x 65
13.129.70

The Virgin and the Archangel Gabriel are shown almost facing each other in front of a fanciful architectural background. The red curtain behind the Virgin opens up in a way that provides room for her figure. She stands in front of a throne with her right hand in a conventional gesture of acclamation, in her other hand holding an open scroll. Opposite her on the left, the angel who has brought her the news of the Incarnation holds a similar scroll with a different inscription.

From above the Holy Spirit represented as a dove, descends in the central tongue of the rays issuing from heaven.

The Annunciation to the Virgin (67)
Greek
Nineteenth century
90 x 69
13.137.70

The fragment belongs to the central part of the upper register of an icon of the Royal Doors. The Archangel Gabriel and the Virgin are represented standing, draped in similar garments of the same colour and turned three-quarter to each other. The latter holds a red handkerchief in her left hand and opens the other in a gesture of acclamation of the message brought to her. Gabriel offers the Virgin a flower, symbol of her virgin conception. Between the two figures the Holy Spirit is shown as a dove among rays.

(67)

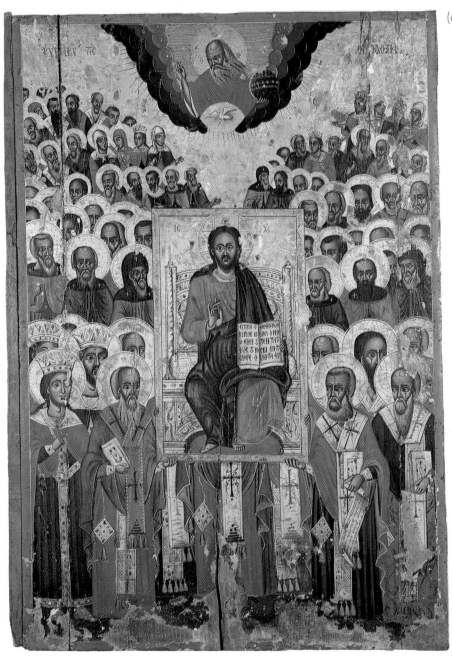

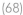

(68)

Triumph of Orthodoxy (68)
Greek
Nineteenth century
105 x 74
13.135.70

The icon represents the Restoration of the Holy Images in 843, at the end of the Iconoclasm. A large icon of Christ Pantokrator is held aloft and surrounded by the patriarch, bishops and other important figures of the time.

At the top, God the Father is represented, isolated from the rest of the image, seated on clouds. His right hand blesses. His left hand holds a globe. The Holy Spirit, shown as a dove, hovers above the head of Christ.

St John in the Wilderness (69)
Greek
Nineteenth century
104 x 73
13.120.70

The icon represents St John in the desert, calling people to repent and be baptised before the approaching 'Kingdom of Heaven.'

St John turned three-quarters to his right fills the icon. As a divine messenger of Christ he is represented with large open wings.

He wears a hairshirt and a blue mantle and thin leather strapped sandals fastened at the ankles. His right hand is extended to the right in blessing. In his other hand there is a long unfurled scroll. The inscription in Greek reads '*Repent, for the kingdom of heaven is at hand*' (Mt 3:2), one of his sermons. He holds a staff with leaves, ending in the shape of a cross with two parallel arms. In front of him on the ground is the chalice with his decapitated head, the symbol of his martyr's death. From the upper left corner, Christ seated in heaven blesses him.

In the background is a hilly landscape with the river Jordan. The lower corner compartments are filled with miniature representations from his life. The one on the left represents his birth and the other his decapitation.

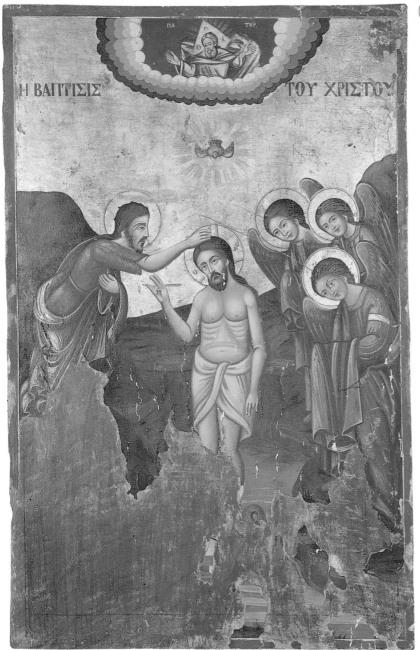

The Baptism (70)
Greek
Nineteenth century
90 x 40
13.116.70

The lower central part of the icon is occupied by the figure of Christ standing in the river Jordan. He is naked except for a loincloth which is wrapped around his waist. His nimbed head leans to the right. His right hand is raised in blessing. The other hand is lowered and blesses the waters of the river Jordan, symbol of the source of earthly life. A piece from a sea-creature survives next to his left foot.

On the left bank of the river is St John the Baptist draped in a skin cloak and a mantle. He leans forward and with his extended right hand touches the head of Christ.

On the opposite bank three angels with open wings bend towards Christ, their hands hidden in their vestments in the traditional manner emphasizing their reverence for the Lord.

God the Father is seated in heaven with both hands wide open in the conventional manner of prayer. His head is adorned with a triangular nimbus and his name is inscribed on both sides. The triangular nimbus symbolizes the Trinity; God the Father, God the Son and God the Holy Spirit. The Holy Spirit, depicted as a dove encircled with rays descends towards the head of Christ.

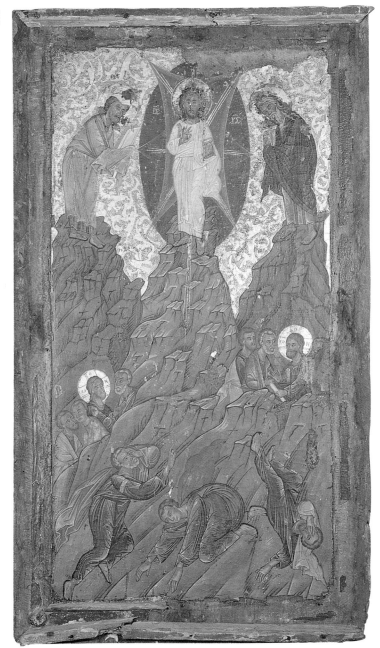

The Transfiguration (71)
Greek
Nineteenth century
105 x 63,5
13.131.70

The story of the transfiguration is related by the gospel writers with varying details (Mt 17:1-14, Mk 9:2-13; Lk 9:28-36). The main fact of the story is that Christ took Peter, James and John up a high mountain which Christian tradition identifies with Mt Tabor. Here he was transfigured shining like the sun and his garments were white as light. Moses and Elijah appeared and talked to him. God the Father spoke from a bright cloud saying 'This is my beloved son, with whom I am well pleased.' The disciples who accompanied Christ fell on their faces in awe. The event is the affirmation by God of Christ as Messiah and Son of God who would fullfill his mission as it is told in the Gospels. It is the announcement of the beginning of the end of time.

The icon shows Christ at the summit of Mt Tabor flanked by the prophets, Moses (left) and Elijah. He is clad in white chiton and himation and stands inside a red eight-pointed star and an oval aureole inscribed with his name. His raised right hand is in the gesture of blessing. His other hand is hidden in the folds of his mantle and holds a book of Gospels. On either side are the witnesses to the miracle, Moses with the tablets of the Ten Commandments and Elijah with a book. The hands of the prophets are hidden in their garments.

In the middle scenes Christ and the Apostles are represented ascending and descending from Mt Tabor.

At the bottom of the icon Peter, James and John are represented in contorted poses, falling on their faces.

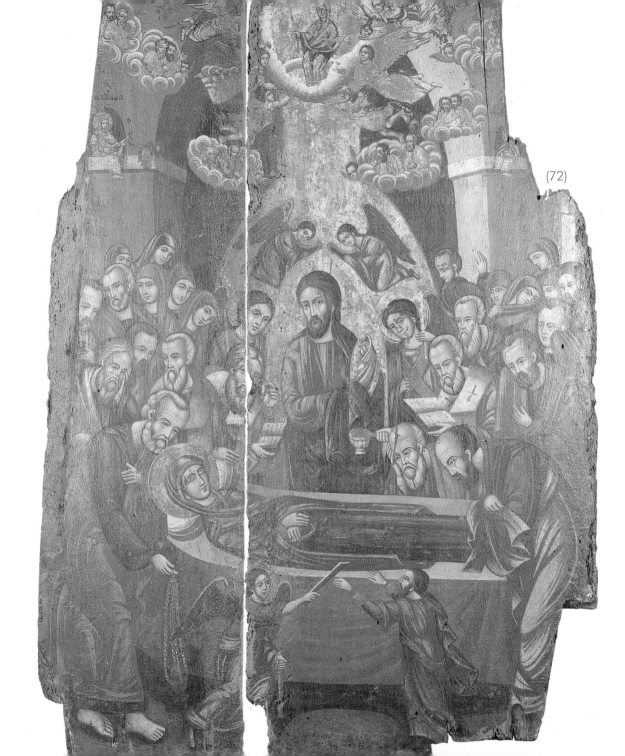

(72)

The Dormition (72)
Greek
Nineteenth century
102 x 83 13.122.70

 The event, which is also known as the Assumption, is not mentioned in the New Testament but deduced from tradition and apocryphal writings. According to these accounts, when she was at the age of sixty (or seventy-two) the Virgin wanted to be with her son. She asked the angel who appeared to her before her death if she could see the apostles. They were snatched up into clouds from wherever they were — such as St John from his preaching at Ephesus — and rushed to her door. Those who were dead were also enabled to rise temporarily for this great occasion. After they were all assembled, Christ came accompanied with angels, troops of prophets and other holy figures.Then the Virgin's soul left her body and flew to the arms of her son.

 The icon represents a very elaborate version of the event. The centre of the triangular setting is the Virgin stretched out on her bier, her eyes closed in death, and Christ holding her soul represented as a baby wrapped in swaddling bands in a small mandorla. He is shown standing on the other side of the bed and in a mandorla to denote his supernatural presence. In the outer zone of the mandorla four angels are represented. The ones who flank Christ carry candles. The bed is surrounded by the apostles, holy men and women. A child has climbed to a high place to see better. These are drawn successfully in a diminishing scale towards the background each expressing his distress by a different gesture of the head.

 At the head of the bed St Peter is distinguished, swinging a censer with his right hand. Opposite him at the foot of the bed St Paul bends to embrace the Virgin's feet. Next to him on the other side is St John, his head resting on his right hand. Among the attendants are two bishops, distinguished by their attire and the book of Gospels in their hands.

 At the bottom, an angel severs the hands of the Jew Athonios who, according to an apocryphal story, tried to overturn her death-bed. The upper register shows the Virgin seated in heaven on the arch of clouds and carried by a group of flying angels. The Twelve Apostles arrive in the form of a 'Spirit in the flesh' in pairs on clouds carried by angels from the uttermost regions of the world through the power of the Holy Ghost, in order to be present at the death of the mother of their Master. From the windows of the symmetrical building flanking the composition the prophet David (left) and another prophet (right) hail the Assumption of the Virgin.

(73)

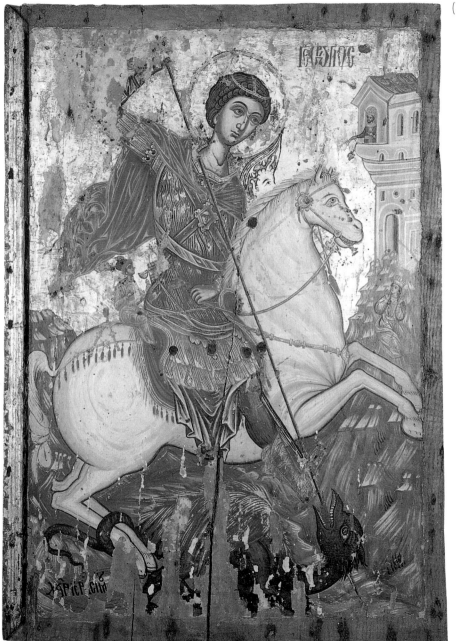

St George and the Dragon (73)
Greek
Nineteenth century
94 x 67
13.114.70

The legend and image of St George, a symbol of the victory of Good over Evil is one of the favourite subjects of Christian art.

St George is depicted on a white charger with elaborate harness and saddle, and in the act of transfixing a black monster with wings of flame. The young Christian from Mytilene in Crete, whom he has saved, sits behind him holding a cup, indicating that he was rescued as he was in the act of serving his Saracen masters.

St George wears chain mail with a girdle across his breast. The clasp of the girdle is decorated with the face of a cherubim. Over this is a red flowing cloak. His nimbed head is adorned with a diadem. He pulls the harness of the horse with his left hand, and with the other hand plunges his long spear into the mouth and through the head of the dragon, whose tail is coiled dangerously around the hind legs of his horse. Blood is dripping from the beast's mouth.

The frightened young princess, who was left to be devoured by the dragon, is seated on the rocks. In the background, from the top of a fortress, her father the king offers the keys of his city to St George.

110

The Revelation of St John the Theologian (74)
Greek
Nineteenth century
58 x 45 13.134.70

The icon describes the vision of St John the Theologian, also known as St John of Patmos, who is also identified with St John the Evangelist and St John the Apostle, as he recounts at the beginning of the book of Revelation (1:10-11).

'I saw seven golden lampstands, and in the midst of the lampstands one like a son of man clothed with a long robe and a golden girdle round his breast; his head and his hair were like a flame of fire, his feet were like burnished bronze, refined as in a furnace, and his voice was like the sound of many waters; in his right hand he held seven stars, from his mouth issued a sharp two-edged sword, and his face was like the sun shining in full strength... Now write what you see... the seven stars which you saw in my right hand, and the seven golden lampstands, the seven stars are the angels of the seven churches, and seven lampstands are the seven churches.'

In the absence of Christian art in the second half of the first century AD St John bases his imagery on the Old Testament allusions, especially those of Daniel and descriptions of the Near Eastern pagan deities.

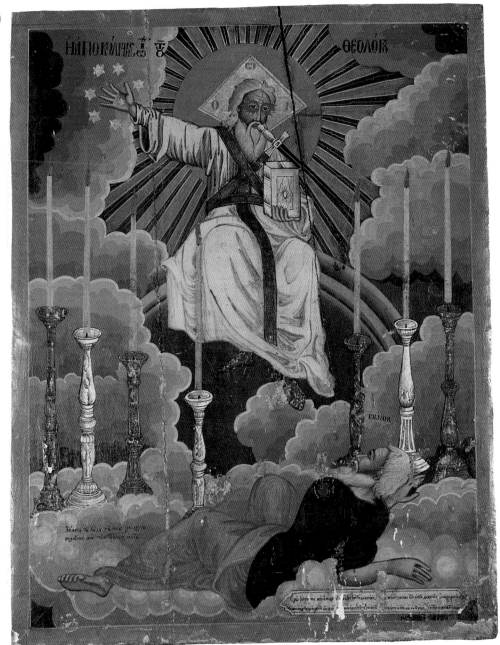

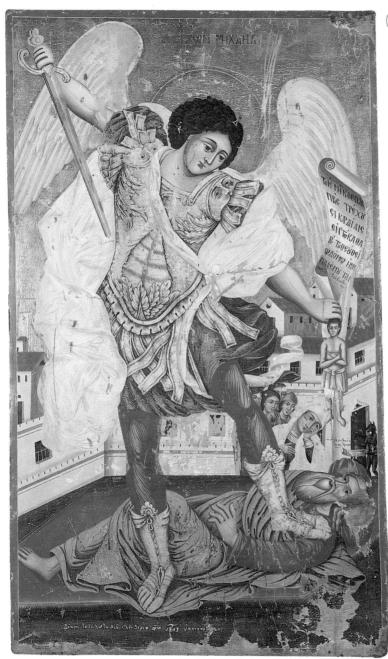

The Archangel Michael (75)
Greek
1849
130 x 77
13.112.70

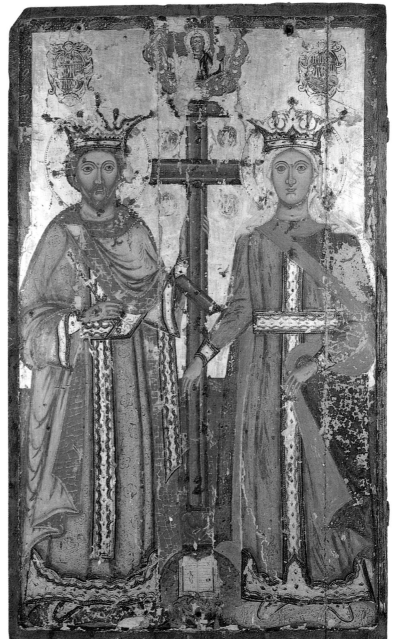

Sts Constantine and Helena (76)
Greek
Nineteenth century
105 x 64
13.130.70

Constantine the Great (AD 306-37) and his mother Augusta Helena are represented full-length dressed in imperial costumes and holding the True Cross between them.

The icon is a symbolic interpretation of the discovery of the True Cross. They are identifed by the inscriptions placed in the baroque medallions above their heads. At the bottom between the two is an open book of Gospels. At the top, Jesus is represented blessing the figures.

Augusta Helena, who was already over seventy, travelled in about AD 325 to Jerusalem and discovered the True Cross and other relics.

According to one tradition, the cross was discovered in a cistern under a Roman temple of Aphrodite. It was distinguished from those of the two thieves by the laying of it on a dying woman who immediately recovered. The True Cross was divided into smaller crosses and some of these were sent to Constantinople.

Constantine received baptism on his deathbed and is claimed to have delayed it because he waited to be baptised like Christ in the waters of the river Jordan. Nevertheless, this was a usual practice in the early days of Christianity. He is known to have stopped persecutions and restored the property that the Church and Christians had lost by previous edicts. He ordered the building of new churches paid for by the imperial treasury. He abolished crucifixion. Sunday, the day on which Christians met and prayed, became a public holiday. After his death he was canonized.

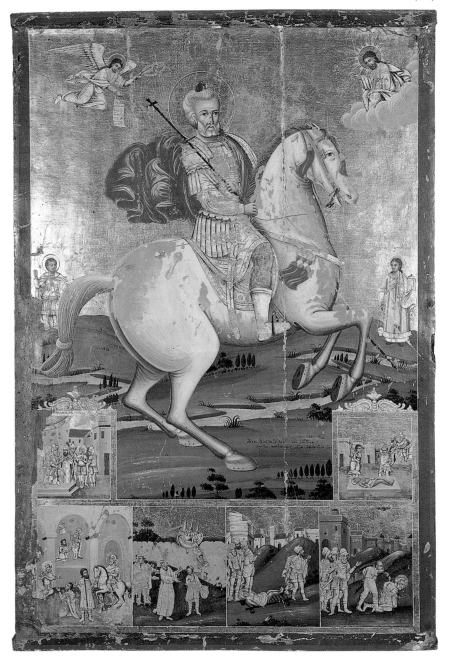

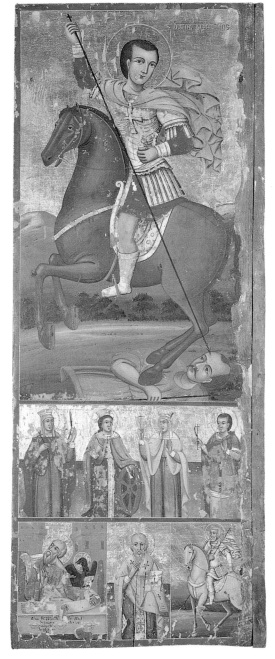

St Menas with Scenes from his Life (77)
Greek
Nineteenth century
100 x 69
13.114.70

The Archangel Michael (78)
Greek
Nineteenth century
115 x 46
13.173.70

(79)

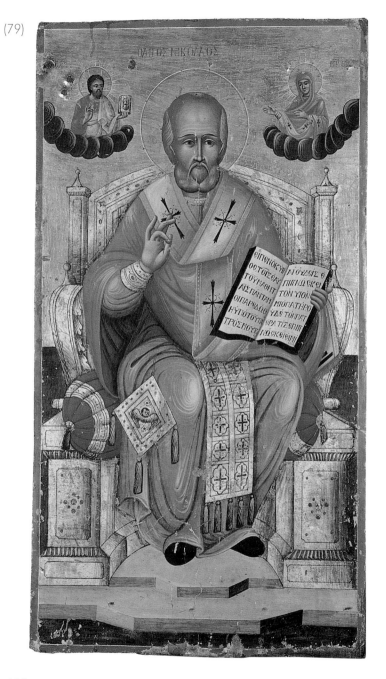

St Nicholas (79)
Greek
Nineteenth century
105 x 56,5
13.123.70

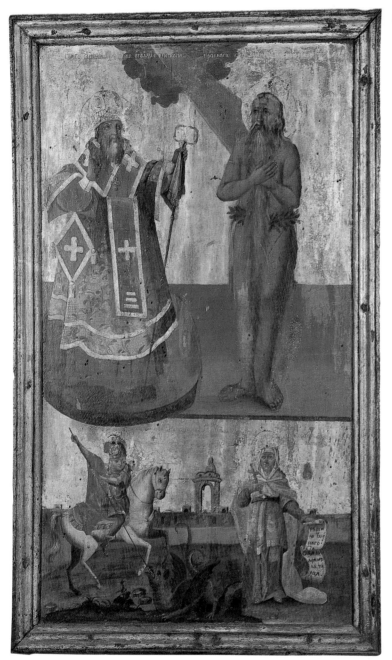

St Onuphrius (80)
Greek
Nineteenth century
70 x 42,5
13.126.70

In the upper register and on the right is St Onuphrius, the fourth-century ascetic who lived in the wilderness of the desert in Egypt and refused to wear any clothes when his old ones had worn out. He is shown naked, but for a loin cloth of foliage. His hair and beard fall to the ground. His hands are crossed on his chest in reverence. A thick ray of light issuing from heaven falls on him.

Tradition has it that Onuphrius was a prince from the city of Thebes, in Egypt — or a monk from a monastery. He felt a vocation for the solitary life and spent sixty years in the wilderness without seeing another soul or uttering a single word except for prayer. He overcame many temptations and was ministered to by a raven who carried food to him, and by angels who brought him Holy Communion each Sunday. During his last hour St Paphnutius, the bishop of Upper Thebes, arrived to comfort him and found him crawling on his knees like a beast. When he died, Paphnutius covered him with his cloak and two lions came out of the desert to dig his grave.

In the lower register St Michael, one of the seven archangels and the patron saint of warriors, is killing the dragon stabbing it in the mouth with his spear. The winged monster is a common symbol of the Devil. On the right, the woman he has saved holds a cross in one hand and an unfurled inscribed scroll in the other.

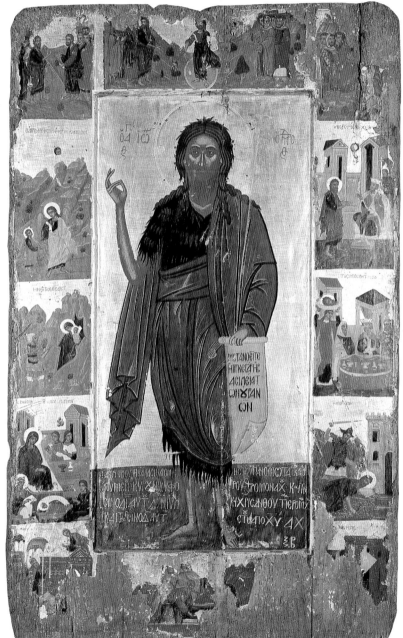

St John the Baptist with Scenes from his Life (81)
Greek
Nineteenth century
103 x 66
13.133.70

The icon represents St John the Baptist surrounded by illustrations of fourteen episodes from his life.

The emaciated figure of John the Baptist occupies the centre. He wears a hair-skin cloak and a mantle. His right hand is raised in blessing; his other hand holds a long staff ending in the shape of a cross and an open scroll. The inscription in Greek reads *Repent, for the kingdom of heaven is at hand* (Mt 3:2). The space on either side of his legs bears an inscription relating that it is dedicated by a few hermits.

The images of his life surround the figure in a continuous or 'epic' style. The scenes which have survived and can be identified beginning in the lowest left bottom corner (clockwise) are: the prayer of Zacharias in the Temple; the birth of John; the flight of Elizabeth; the angel leading John into the wilderness; John bearing witness to Christ(I); John bearing witness of Christ(II); John before Herod; John's head on a platter borne by Salome; beheading of John.

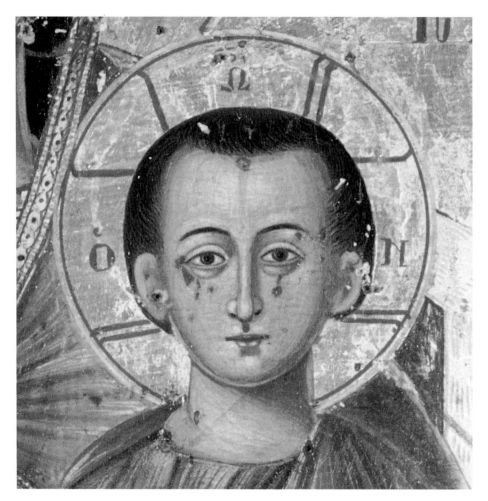

The Virgin Enthroned with Child (83). Detail. The Tokat Museum.

ICONS
from the
TOKAT MUSEUM

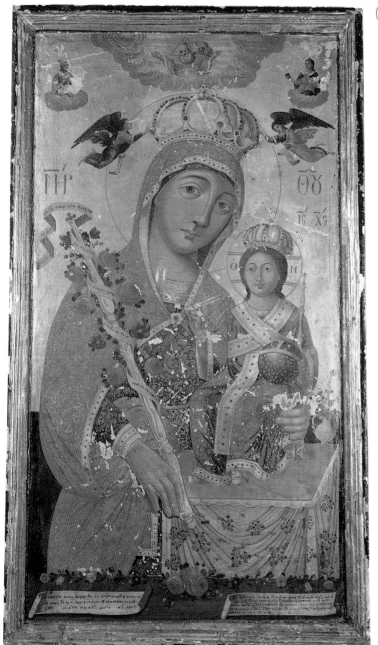

(82)

The Virgin Enthroned with Child (82)
Greek
Nineteenth century
105 x 53
48.6.30

The Virgin is shown half-length standing at the centre. Her right hand holds a sceptre with an entwined scroll and flower branch. The infant Christ sits enfolded in her left arm. He holds an orb and a cross-sceptre in his left hand and the other is raised in blessing.

On either side angels bearing inscribed scrolls crown the Virgin; this act acknowledges her as the Mother of God. Above them two prophets are seated on clouds. God the Father in heaven is shown blessing.

The placard in the lower left corner is about the painter of the icon. The one in the opposite corner belongs to the dedicator.

The Virgin Enthroned with Child (83)
Greek
Nineteenth century
105 x 53
48.7.30

Christ Pantocrator (84)
Greek
Nineteenth century
105 x 53
48.10.30

(83) (84)

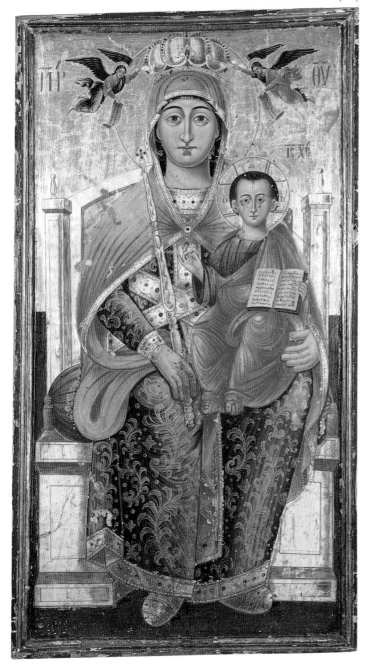
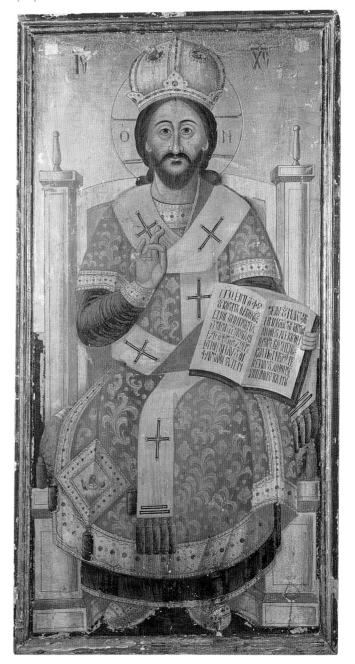

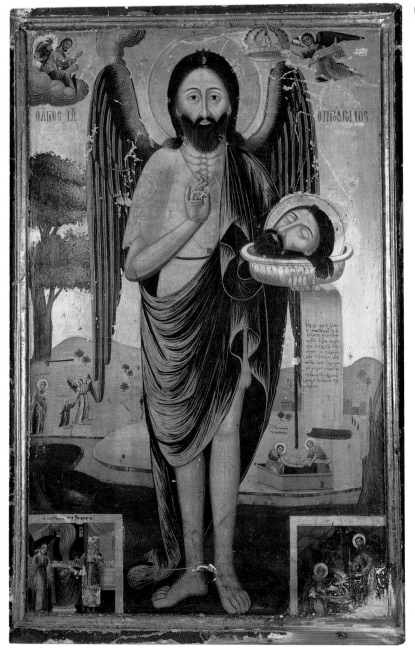

St John in the Wilderness (85)
Greek
Nineteenth century
106 x 67,5
48 .4.30

 St John fills the icon with an angel's wings as the divine messenger from the desert. He was sent to earth as the precursor to prepare the way for Christ as recounted in Mark (1:2) 'Behold, I am sending my messenger ahead of you; he will prepare your way.'

 His right hand is raised to his chest in the act of blessing. His other hand holds a staff whose top is adorned with a small cross, an unfolded scroll which probably contains the words of Isaiah's prophecy and a dish with his decapitated head foreshadowing his death as a martyr. His long hair falls on his shoulders. Over his skin garment he wears a loose mantle leaving his legs uncovered, falling to the ground. In the upper left corner Christ is shown seated in heaven and blessing. An angel carrying an open scroll and a jewelled crown approaches from the opposite corner.

 In the background the common motifs of the subject are represented: a tree and an axe — the symbol of his preaching which summoned the people to repentance, saying, 'Even now the axe lies at the root of the trees. Therefore every tree that does not produce good fruit will be cut down and thrown into the fire.' (Lk 3:9); other subjects include his mother Elizabeth, his being guided by an angel into the wilderness as a child 'to remain until he comes of age,' and his entombment.

 The lower corner compartments have square miniature representations from his life.

St George and the Dragon (86)
Greek
Nineteenth century
104,5 x 64 509

The icon represents the most popular military saint of the Christian tradition mounted on a white horse in the act of killing the dragon, the common symbol of Evil or the Devil.

He is shown as a beardless youth wearing a red diadem. On his cuirass which bears a cross in the front he wears a pink flowing cloak. The small figure who is sitting at the back is the young Christian from Mytilene, in captivity on the island of Crete. Tradition has it that the boy was forced to serve his Saracen masters with food and drink, but in the very act of offering a glass to one of his captors was rescued by St George and carried home over the Aegean.

St George is seen plunging his long spear into the mouth of the dragon, a monster with pink wings and flames coming out of its mouth. On one side the princess is shown running in fright. She was chosen by lot and left to be devoured by the dragon when the city had run out of sheep to feed the beast. Her parents, the king and the queen of the city of Silena — in the province of Lybia — stand on the top of the castle. Two keys hang from the end of the cord in the king's hand. After St George killed the dragon the king, his daughter and the people of the city accepted Christianity. In the upper right corner Christ is shown blessing from heaven. A flying angel approaches the saint carrying a crown and an open scroll.

The episode circulated in various forms and is thought to be a late medieval addition to the biography of St George. He is said to have been tortured to death when he refused to recognize the imperial cult during the reigns of the Tetrarchs at the beginning of the fourth century. The lower register of the icon is reserved for the miniature scenes from his passion.

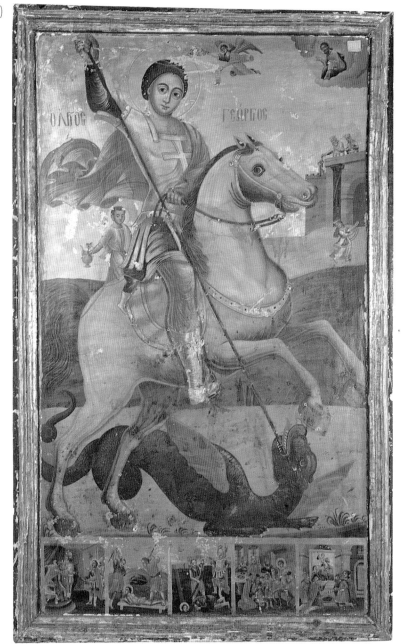

GLOSSARY

ACHEIROPOIETOS
Not made with human hands.

ANASTASIS
The resurrection of Christ, represented in art by his trampling the gates of hell and freeing Adam, Eve, etc.

BLACHERNITISSA
An image of the Mother of God with her hands raised in front of her, palms displayed, in the manner of her icon kept in the church of Blachernai in Constantinople.

CHITON
An undergarment fastened on the shoulders and tied around the waist. Short for men, long for women.

CLAVUS (pl CLAVI)
A decorative band of status woven into or sewn onto clothing.

DEISIS
Intercession. A composition which shows the Mother of God and St John the Baptist flanking Christ with gestures of entreaty.

DORMITION
From Greek *koimesis*, 'falling asleep'; used for the death of the Virgin.

ELEOUSA
From the Greek *eleos*, 'mercy' or 'pity'.

HIMATION
A loose outer garment made of a rectangular piece of cloth.

HODIGITRIA
From the Greek *odos*, the 'way'. 'Who shows the way'.

ICONOCLAST
An enemy and destroyer of icons, 'Image-breaker'.

ICONODULE
A person who venerates icons.

ICONOSTASIS
The wall in an Orthodox church which separates the congregation from the sanctuary and is decorated with icons.

MANDYLION
A cloak, a small cloth, a napkin.

MAPHORION
A long sleeveless tunic which covers the head and body. The traditional attire of the Mother of God and the Holy Women.

MONOPHYSITISM
A doctrine that absorbs the human nature of Christ into his divine nature; condemned at the Council of Chalcedon in 451.

OMOPHORION
An ecclesiastical vestment in the Orthodox Church. It consists of a long, wide band of material worn around the neck in such a way that it covers both shoulders and hangs from the left with one end in front and the other behind.

ORANT, ORANS
The early Christian attitude of prayer, with arms extended sideways and upward.

PANTOCRATOR
All-powerful or almighty. 'He who governs all'.

ROYAL GATES
The central two-leaved door or gate in an iconostasis.

THEOTOKOS
'God-bearer', or the 'Mother of God'. From Greek 'theos,' 'God' and 'tikto', 'to give birth'. The name of the Virgin in the eastern countries. On Greek icons the Mother of God is marked with its abbreviation MPØY (Meter Theou). The title was originally used for the Egyptian Goddess Isis, referred to as 'Mut Netzer', or the 'Mother of God'.

TEMPLON
Screen separating the nave from the sanctuary.

TRIPTYCH
Three panels of wood, metal, etc joined usually by hinges.

SELECTED BIBLIOGRAPHY

D. Coomler, The Icon Handbook, Templegate Publishers, Springfield, ILL, 1995

E. Sendler, *The Icon, Image of the Invisible,* Oakwood, Publications, Torrence, CA, 1995

J. Baggleus, *Doors of Perception*, ST Vladimir's Seminary Press, Crestwood, NY, 1995

J. de Voragine, *The Golden Legend,* vols I, II, Princeton University Press, Princeton, NJ 1995

M. Zibawi, *The Icon*, The Liturgical Press, Collegeville, MINN 1993

L. Ouspensky, Theology of the Icon, vols. I, II, St Vladimir's Seminary Press, Crestwood, NY, 1992

M. Ouenol, The Icon, *Window on the Kingdom*, St Vladimir's Seminary Press, Crestwood, NY, 1991

P. Evdokimov, *The Art of the Icon,* Oakwood, CA, 1991

A. Grabar, *Christian Iconography, A Study of Its Origins*, Princeton, University Press, NJ, 1980